THE ART OF
MAKING MEMORIES

THE ART OF
MAKING MEMORIES

HOW TO CREATE AND
REMEMBER HAPPY MOMENTS

NOV 1 1 2019

MEIK WIKING

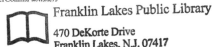

WILLIAM MORROW
An Imprint of HarperCollins*Publishers*

The photography credits on pages 284 to 286 constitute an extension of this copyright page.

THE ART OF MAKING MEMORIES. Copyright © 2019 by Meik Wiking. All rights reserved. Printed in the United States of America. No part of this book may be used or reproduced in any manner whatsoever without written permission except in the case of brief quotations embodied in critical articles and reviews. For information, address HarperCollins Publishers, 195 Broadway, New York, NY 10007.

HarperCollins books may be purchased for educational, business, or sales promotional use. For information, please email the Special Markets Department at SPsales@harpercollins.com.

Published in the United Kingdom in 2019 by Penguin Random House UK.

FIRST U.S. EDITION

Library of Congress Cataloging-in-Publication Data has been applied for.

ISBN 978-0-06-294338-5

19 20 21 22 23 LSC 10 9 8 7 6 5 4 3 2 1

CONTENTS

INTRODUCTION

To paraphrase one of the greatest philosophers of the twentieth century, Winnie-the-Pooh: you don't know you are making memories, you just know you are having fun.

That was what I was doing until this year, when something happened: this year, I turned forty. Now, things are changing.

Last week, I found a hair right in the middle of my forehead. And we're not talking about one hair that decided to move to the suburbs of the eyebrows here. No, we're talking about a hair that wanted to leave civilization behind. Go off grid. Into the wild. The Thoreau of eyebrow hairs. Turning forty means tweezers are your new best friend.

When you turn forty your language changes; you are now entitled to use the word "nowadays." You see colors differently: hair is not grey—it is "executive blond." You find joy in new things, like leaving the oven door open after roasting vegetables to "get the benefit of the heat."

But turning forty also means that I have lived half my life, statistically speaking. Life expectancy for men in Denmark is around eighty years and, while I may not believe in life after death, I strongly believe in making the most of life before death.

So far, that life for me has yielded 40 years, or 480 months, or 14,610 days. Some days pass us by without leaving a trace—and some happy moments stick with us forever. Our lives are not the days that have passed, but the days we will remember forever. That got me thinking: Which of those 14,610 days do I remember? And why? How can I make more of my days more memorable in the future? How can we retrieve happy memories from the past and create happy memories in the present?

I remember every first kiss—but have trouble remembering anything that happened in March 2007. I remember the first time I tasted a mango—but have no recollection of any meal I had when I was ten years old. I remember the smell of grass in the field we kids would play in—but I struggle to remember the kids' names.

So what are memories made of? Why is it that a piece of music, a smell, a taste, can take us back to something we had forgotten? And how can we learn to create happy memories and be better at holding on to them?

I have asked and tried to answer these questions as a happiness researcher. My job is to study happiness, to understand what makes people happy, to uncover the good life and understand how we can make life better. At the Happiness Research Institute, which is a think tank dedicated to well-being, happiness and quality of life, we explore the causes of happiness and work towards improving the quality of life of people across the world.

Some days we remember because they were sad. They are part of our human experience, part of our memory and part of what makes us who we are. However, as a happiness researcher, my main interest is in exploring what ingredients produce happy memories.

Happiness research suggests that people are happier with their lives if they tend to hold a positive, nostalgic view of the past. Nostalgia is a universal and ancient human emotion and, today, academics across the world are

studying how it can produce positive feelings, boost our self-esteem and increase our sense of being loved by another. This means that long-term happiness can depend on your ability to form a positive narrative of your life.

I focused my research on finding out what happy memories are made of. It has been a tricky question to pose. How do you ask strangers about memories without sounding all Hannibal Lecter? "Tell me about your childhood memories, Clarice."

I have also asked and tried to answer these questions as an archaeologist venturing into my own past, searching to retrieve lost treasures in the form of happy memories.

I've revisited my childhood home—a home the family sold twenty years ago—to discover how the scent of a place could trigger memories. Thank you to the new owners, who did not slam the door in my face when I asked, "Can I come in and smell your house?"

With this search for lost treasures comes the understanding that our childhood memories are created, shaped and retrieved in collaboration with our parents. My mother died two decades ago, and with her an entire continent of memories vanished. In that sense, this story is also a search for Atlantis. A quest for memories lost.

I wanted to retrieve and restore them because our memories are the cornerstones of our identity. They are the glue that allows us to understand and experience being the same person over time. They are our superpower, which allows us to travel in time and sets us free from the limitations of the present moment. They shape who we are and how we act. They influence our mood and help form our dreams for the future.

1,000 HAPPY MEMORIES

In 2018, we conducted a massive global study around happy memories at the Happiness Research Institute: the Happy Memory Study.

"Please describe one of your happy memories," we asked. We were not searching for any particular memory, so we asked people simply to write down the first happy memory that came to mind.

I was overwhelmed by the response we got. The Happy Memory Study is, as far as I know, the biggest global collection of happy memories to date.

We received more than a thousand answers from all over the world. Responses came from seventy-five countries, from Belgium, Brazil and Botswana to Norway, Nepal and New Zealand. Happy memories were pouring in.

Happy memories from different corners of the planet, from different generations, from different genders, from people who were sad and from people who were high on life. However, despite the diversity in sources, I could relate to every happy memory. I understood why each moment was a happy memory for that person. We might be Danish, Korean or South African, but we are first and foremost human.

a closer look at the happy memories, patterns started to
e stories. People were remembering experiences that were
ingful, emotional and engaged the senses.

nce, 23 percent of the memories were novel or extraordinary
e nces such as visiting a country for the first time; 37 percent were
meaningful experiences such as weddings and births; and 62 percent
involved several of our senses: for example, one woman saw, smelled and
tasted the poblano peppers which her mother used to roast on the stove
when she was a child.

We also asked people why they thought they were remembering a
particular memory and 7 percent mentioned that they had now been turned
into stories or outsourced in mementos, diaries and photographs.

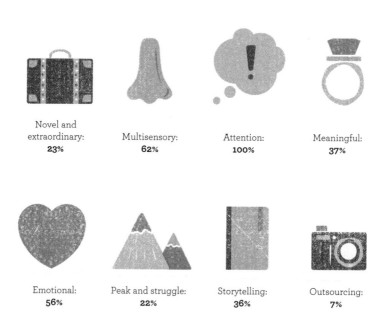

| Novel and extraordinary: **23%** | Multisensory: **62%** | Attention: **100%** | Meaningful: **37%** |

| Emotional: **56%** | Peak and struggle: **22%** | Storytelling: **36%** | Outsourcing: **7%** |

Note: One memory can tick several boxes.

We received memories about the big days in people's lives: stories of wedding days and their daughter's first steps.

We received memories about the simple things: stories of the feeling of the sun against their skin, eating cheese-and-pickle sandwiches while watching soccer with their dad or waking up next to the one they love.

We received memories about the adventures in life: stories of dogsledding, traveling alone to Italy or moving to Amsterdam.

And memories about the crazy times: stories of haystack-jumping, orange-shooting cannons or trying to open a bottle of wine with a sports shoe on a frozen lake.

And memories about the victories: stories of the exams they passed, the time they won the soccer game against all odds or when they dared take the mic on stage and share what they had written.

Some memories were about the everyday: stories of watching the sun shine through the window, walking into a bookshop or spending the afternoon with their mum eating cake and watching *Keeping Up Appearances* (a British sitcom in which the snob Hyacinth Bucket attempts to convince the world that her surname is pronounced "Bouquet').

And other memories were of connecting with nature: stories of swimming in a lake in Switzerland at midnight under the moon and the stars, walking in the Norwegian wilderness or looking out over Big Sur with no one to answer to—just them and the Pacific Ocean.

Many of the memories were of the fun times: stories about water-balloon battles, snowball fights or skating on smooth ice in an empty ice rink.

And memories about the times people were there for us: a hug from a loved one at just the right time, or the colleagues who decorated our work space because they knew we were going through a tough time.

All these memories are small pieces of the puzzle and add up to show what happy moments are made of, what ingredients go into happy memories and why we remember what we remember. We will look at each of these ingredients in the chapters to come.

THE MEMORY MANIFESTO

8 INGREDIENTS FOR HAPPY MEMORIES

Harness the power of firsts. Seek out novel experiences and make days extraordinary.

Make it multisensory. Go beyond sight. Memories can also have sounds, scents, touch and tastes.

Invest attention. Treat your happy moments like you would your date. Pay attention to them!

Create meaningful moments. Make meaningful moments memorable moments.

Use the emotional highlighter
pen. Get the blood flowing.

Capture peaks and struggles.
Milestones are memorable, but
the struggle to reach one
is unforgettable.

Use stories to stay ahead of the
forgetting curve. Share stories.
Do you remember the time we . . . ?

Outsource memory. Write,
photograph, record, collect.
Be Marie Kondo's archenemy.

MOOD MANIPULATION

One aspect of the Happy Memory Study we did at the Happiness Research Institute was to explore whether we could impact people's momentary happiness by getting them to think of a happy memory.

We asked people to imagine a ladder with steps numbered from zero at the bottom to ten at the top. "Suppose we say that the top of the ladder represents the best possible life for you and the bottom of the ladder represents the worst possible life for you. On which step of the ladder do you feel you personally stand at this time?" This is a question that captures a person's satisfaction with life, their overall happiness—a long-term happiness, where it takes more to improve the level of satisfaction. It is also the question that is used in the World Happiness Report.

We also asked people, "To what extent do you feel happy right now, where zero means extremely unhappy and ten means extremely happy?" This is a question which allows for influences such as what day of the week it is, what the weather's like, current events—or perhaps thoughts about the past.

What we found was a small but significant correlation between the number of words the participants had used to describe their happy memory and their happiness right now. The more words people used going down the lane of happy memories, the happier they were in the moment. We cannot be sure that they were happier because they were thinking of a happy memory—it could also be the other way around. If you are in a good mood, you might be more likely to spend more time answering silly questions from scientists—but it is an area with potential for further research.

Also, something interesting came to light. I know these are divided times and I would hate to throw fuel on these divisions, but I feel it is my obligation as a scientist to report the truth. As I went through people's memories I could not help but notice that seventeen people mentioned their dog and only two people mentioned their cat. So, what does this mean? Well, one theory that can explain it is prevalence. If more people have dogs than cats, then dogs are more likely to have a part in happy memories. A second theory is that dogs are simply pawesome. *Who's* a good theory? *You're* a good theory!

EPISODIC MEMORY

One question we ask is "What did you have for dinner last night?" Try traveling back in time to last night. What did you eat? Where were you, and who were you with? What did you have to drink? Did you prepare the food, and what did you do with the dirty dishes?

Now tell me the answers to the following questions: What is the capital of Cambodia? Which is the tallest mountain in the world? Who was British Prime Minister at the end of the Second World War?

The retrieval of information about dinner last night is very different from the retrieval of information about Winston Churchill. It is the difference between remembering and knowing. It is our autobiographical or episodic memory, as opposed to our semantic memory.

When talking about memory, we need to make the distinction between these two types of memory. Semantic memory is the ability to remember that the capital of France is Paris. Episodic memory is your ability to remember *your* trip to Paris. This distinction was first made by Endel Tulving, psychologist and cognitive neuroscientist at the University of Toronto, in 1972. Straight into your semantic memory storage facility—see what I did there?

When you retrieve memories from your episodic memory it involves you traveling back in time and re-experiencing them. When you access your memory to find out who was Prime Minister in Britain at the end of the Second World War it is a very different experience. You probably have no idea of when and where you gained that knowledge. It is just something

you know. It is impersonal. The memory contains no taste, no smell, no sound. It is lacking the sensory richness your memory of last night's dinner may hold.

Episodic memory covers the personal, unique and concrete experiences we can retrieve from our own past. Semantic memory is timeless knowledge that we share with the world about the world.

In addition, episodic memory can be seen as a sixth sense—a sense for the past. It is our ability to travel in time. No need for a DeLorean at 88mph, Marty McFly!

For Tulving, it was the time travel—the sense of re-experiencing an event—that was the defining element of episodic memory. Your episodic memory is also often represented in short time slices of an experience with a perspective—your point of view—lined up roughly in order of occurrence. You panfried the fish, the radio was playing Nat King Cole, you sipped your glass of wine, it was cold and dry, you burned your finger on the pan, cursed out loud, your spouse said, "What's happened?" from the other room. "Nothing," you said. "Dinner's ready!" You took the vegetables out of the oven. Left the oven door open, felt the heat, smiled and sat down.

Your episodic memory is very complex and develops later in childhood than your semantic memory. You learn facts about the world before you can remember your own personal experiences in the world. Both memory systems are part of your long-term memory; the third type identified by Tulving is procedural memory. (In addition to these types of long-term memory, there is also short-term memory.) However, while semantic and episodic memory are explicit, procedural memory is implicit. It allows you to perform commonly learned tasks without thinking about them. It is how you remember to ride a bike, brush your teeth, do the dishes, sign your name or walk like an Egyptian when The Bangles play. In this book, we will focus on episodic memory. If you want to remember how to dance the Macarena or memorize pi to ten thousand decimals, you're on your own.

HAPPY MEMORIES ARE GOOD FOR YOUR HEALTH

Because of my work, I often speak with people who are or have been living with depression.

One of the common factors among them is that when they are at their lowest, they are not only unable to feel any level of joy but are also unable to remember any point in time where they had experienced joy. As well as being unable to retrieve any happy memories, people who suffer from depression also tend to ruminate on negative events.

Fortunately, research is being done to help people struggling with depression. Dr. Tim Dalgleish, a clinical psychologist at the University of Cambridge, helps those with depression by employing the method of loci (which uses visualization and spatial memory) to help them summon happy memories more easily. In one study, Dr. Dalgleish and his colleagues worked with forty-two people with depression and helped them generate fifteen happy memories to fall back on when they were feeling low.

This requires some effort, as depression impairs the ability to retrieve positive memories. Some participants would respond, "I don't have fifteen positive memories," so the researchers worked with them to flesh out and make the memories more vivid, with richer sensory details of smells, colors and sounds. The next step was to place the fifteen memories in familiar homes, or along routes, using the loci method. A control group underwent a different form of training in which they were encouraged to form the memories into meaningful sets, or chunks, and rehearse them—a strategy which is often used in preparation for exams.

Both groups managed to improve their memory recollection to near-optimal levels after one week of training. However, one week later, the researchers phoned the participants without warning and gave them a recall test. Only the participants who had used the loci method maintained the ability to recollect the happy memories.

However, it's important to note that, even though the participants reported feeling better, they did not score significantly better on the depression scale. Furthermore, since the participants were aware of what the experiment was trying to achieve, it is possible that such a self-reported improvement could be a placebo effect. Nevertheless, being able to retrieve happy memories is a mark of progress and, today, nostalgia is considered a useful psychological mechanism which counteracts loneliness and anxiety and makes people feel happier.

HAPPY MEMORY TIP:
ENTER THE PALACE

As I enter my childhood home, the Three Musketeers are fighting in the hallway.

I duck to avoid Porthos's swing and roll into the kitchen. Beethoven is there, taking a chicken out of the oven. There is a fireplace in the kitchen, in front of the seating area. Pope Francis is trying to get the fire going, but he gets soot on his white hat and starts to swear. In the room next door, Neil Armstrong is playing the piano. He is wearing his space suit, so each finger hits several notes at a time.

This is not a dream. This is a carefully curated memory palace. Allow me to explain. Several of the memory techniques we apply today were developed back in ancient Greek and Roman times. One of them is the method of loci ("place" in Latin)—also known as the memory palace. Or, if you are into the BBC crime drama *Sherlock* (and who isn't?), Benedict Cumberbatch's Holmes refers to it as the "mind palace."

According to legend, the method was first used by the Greek poet Simonides in 500 BC. He was also known as "He of the honey tongue" and would entertain with poetry and odes at feasts and banquets. On one of these occasions, after his performance Simonides left the temple where the feast had taken place and, in that very moment, the roof collapsed, killing everyone inside. The bodies were crushed so badly it was impossible to identify them. Yet Simonides was able to picture the scene from earlier that evening and remember who had been sitting where in the room. Later, he reflected on the experience and formulated the method of loci.

The method is often used today in memory competitions, where one of the disciplines is to remember as rapidly as possible the order in which the cards in a deck fall. In advance, the participants create memory palaces—places they know well, such as their childhood homes or a familiar route. They also assign a character or person to each card of the deck. In my system, the six of spades is Marilyn Monroe. The Jack of hearts is my brother. The King of clubs is King Kong.

I've made it so all the clubs are fictional characters (Robinson Crusoe or Jack Sparrow); hearts are people I know personally; diamonds are contemporary celebrities (Donald Trump or the Danish Queen Margaret); and spades are celebrities or historical figures who are now dead (Frank Sinatra or Cleopatra).

In addition, for example, all the eights are people who wear glasses (Gandhi); the nines are Germans (because "nine" sounds like the German for "no'); and fours are people with four-legged friends (so Tintin with Snowy).

The combination of the number of the card and the suit makes it easier to remember; for instance, the nine (German person) of spades (dead historical figure) is Beethoven.

When the first card is shown, you place the character you associate with it in the first location in your memory palace or route and then

create a mental image of the situation they find themselves in. It is more effective if they perform an action—the dirtier, the naughtier, the more politically incorrect, the better.

So, try and remember: who was taking the chicken out of the oven in the kitchen? It was Beethoven. And who was trying to light the fire, got soot on his clothes and swore? Pope Francis, right? (For me, the ten of diamonds.) Who was playing the piano? Neil Armstrong in his space suit: the ace of spades. One small musical step for man, one lasting picture in your mind.

A word of warning. As I was working on the mnemonic system above, I was on a flight to Canada. I became so caught up in learning how to memorize a full deck of cards, I left my laptop in the pocket in front of my seat. I am fully aware of the irony. If you have read *The Little Book of Lykke*, you will know that this is not the first time I have left my computer on a plane. To avoid this happening a third time, I now place one of my shoes in the seat pocket with my computer.

Using the memory palace, I can now memorize the order of a deck of cards in around six minutes, but the memory palace can be used for more important things than party tricks.

NOSTALGIA — IT'S NOT WHAT IT USED TO BE

One of my favourite scenes in Mad Men—*the TV series set in a fictional sixties advertising agency—is from the episode called "The Wheel."*

Kodak has developed a new round slide projector and the company is very attached to the idea of calling it "the wheel" in the advertising campaign. At the meeting with the Kodak clients, Don Draper—head of Creative at Sterling Cooper—turns on the projector and flips through old slides of him with his family. His wife. Their children. Happy moments. Happy memories.

Don Draper talks about the skills required in advertising and says that the most important idea in advertising is: *New!* But he also talks about the opportunity to create a deeper bond with the product. A sentimental bond: Nostalgia. It is a delicate, but potent, twinge in the heart. The projector is not a projector—it is a portable nostalgia generator, a time machine that allows people to go back in time, to a place they ache to go to again. It is not a wheel—but a carousel—that allows us to be children again, and allows us to revisit places where we were loved.

The scene is fictional, but the use of nostalgia as a marketing tool is very real. From expensive watches which promise nostalgia in the future—"You never actually own a Patek Philippe. You merely look after it for the next generation"—to chicken nuggets.

When McDonald's removed antibiotics and artificial preservatives from their nuggets in 2016, they created an ad campaign built on nostalgia. A split screen shows a young boy to the left and a young girl to the right. Cue music: an acoustic version of Cyndi Lauper's "Time After Time." The young boy passes the things he loves over to the young girl. His bike. His joystick. His toy. As he passes them, they change from an eighties product into a contemporary one.

If you are a parent, you want to give your kids something better than what you yourself had. At the end of the advertisement the young boy passes a chicken nugget to the girl. He slides over to her side of the screen and he is now no longer a boy, but a grown-up—and surprise!—it's her dad. The advertisement is very well done. I almost tear up. And I don't even like chicken nuggets.

According to *Forbes* magazine, nostalgia is employed in marketing because "reliving positive memories and beloved icons from the past feels good." In addition, the article "An Involvement Explanation for Nostalgia Advertising Effects" by Muehling and Pascal published in the *Journal of Promotion Management* in 2012 concludes that nostalgia in advertising influences how much attention people pay to the advertisement and how positively they view the brand or product being advertised. Consequently, nostalgia is today a natural ingredient in advertising, TV programs, museum exhibitions, fashion, music, interior design and politics.

We watch *Mad Men* and *The Americans* (a spy series set in the eighties). We buy vintage clothes and furniture and vinyl. We visit antique shops and look at fountain pens brought to Britain by German immigrants in the exhibition "Things We Keep" at the German Historical Institute. All while President Trump promises to make America "Great Again." Nostalgia. It is delicate but potent. But it wasn't always like this.

The term "nostalgia" was coined in 1688 by Swiss physician Johannes Hofer in his medical dissertation. Hofer considered it a medical or neurological disease. Symptoms included excessive thinking about home, weeping, anxiety, insomnia and an irregular heartbeat. It was thought to

be similar to paranoia, except that nostalgia was manic with longing and melancholia and specific to a place.

"Nostalgia" is a compound word consisting of *nostos* ("return" or "homecoming") and *algos* ("pain") and was inspired by history's earliest and most epic tales of homesickness.

After emerging victoriously from the Trojan War, Odysseus and his crew set sail for Ithaca, his homeland. There, he would be reunited with his wife, Penelope. The journey between Troy and Ithaca is only 565 nautical miles, but it took Odysseus ten years to complete. Outsmarting Cyclops, resisting sirens and surviving the wrath of Poseidon is rather time-consuming, I suppose. However, seven of those ten years were spent on the island of Ogygia with Calypso. The beautiful nymph fell in love with Odysseus and offered him immortality if he would become her husband. Yet he still longed for home and his wife. "Penelope cannot compare with your stature or beauty, for she is only a mortal, and you are immortal and ageless. Nevertheless, it is she whom I daily desire and pine for. Therefore, I long for my home and to see the day of returning." To cut a long story short, Odysseus returns home, finds his faithful wife surrounded by suitors and goes *Game of Thrones* on their asses.

Johannes Hofer claimed that the disease of nostalgia was often found in soldiers, especially Swiss mercenaries from the Alps who were fighting on the lowlands and plains of Europe and missed the Swiss mountains. Suspected causes were stark differences in atmospheric pressure, which were thought to cause brain damage, and damage to the eardrums and, again, the brain from the constant clanging of cowbells in the Swiss Alps. In the eighteenth and nineteenth centuries some doctors even searched for a "pathological nostalgia bone." By the early nineteenth century, however, nostalgia was no longer regarded as a neurological disorder but considered a form of depression—a view that lasted well into the twentieth century.

Today, nostalgia is a subject of scientific study and different scales have been developed to measure people's view of the past as opposed to the present and how prone to nostalgia people are. For instance, the Holbrook Nostalgia Scale asks people to agree or disagree with statements such as "Products are becoming shoddier and shoddier," "Steady growth in Gross National Product has brought increased human happiness" and "Things used to be better in the good old days." Southampton University is one of the leading academic centers in this area, and the Southampton Nostalgia Scale ask questions such as "How valuable is nostalgia for you?" and "How often do you call nostalgic experiences to mind?"

And there are good reasons to study nostalgia. First of all, it is something we all experience. A lot. In one study of British undergraduates, over 80 percent reported experiencing nostalgia at least once a week. And this is felt universally. Across the world, we reminisce about our loved ones and special events. About weddings and sunsets and the time we stayed up all night, warmed by the fire, and watched the sunrise over the ocean. We are often the lead character in these stories, but they revolve around experiences which demonstrate our connection with people who are close to us.

Second, there is a growing body of evidence that nostalgia produces positive feelings and boosts our self-esteem and sense of being loved and at the same time reduces negative feelings such as loneliness and meaninglessness.

Our satisfaction with life—our happiness—depends in part on whether we have, or create, a positive narrative of our life. When we look back, do we see flashes of flaws and failures, or do we see moments of joy, moments of happiness?

So which ingredients should we put into nostalgic-to-be memories? How do we best preserve and retrieve happy moments from places or events where there are no souvenirs? What are happy memories made of and what makes memories remain memories? Let's take a closer look.

CHAPTER 1

HARNESS THE POWER OF FIRSTS

THE REMINISCENCE BUMP

You know that song "Glory Days" by Bruce Springsteen?
If not, pass me a few gin and tonics and I'll sing it to you.
I warn you, you might want to cover your ears. If you listen to
the lyrics, the song is about how much people enjoy talking
about the old times. The good times. The glory days.

Ask any older person to recall some of their memories and there's a good chance they will tell you stories from a period in their life when they were between the ages of fifteen and thirty. This is known as the reminiscence effect, or reminiscence bump (both terms are trickier to work into song lyrics than "glory days").

Memory research is sometimes conducted by using cue words. If I say the word "dog," what memory comes to mind? Or "book"? Or "grapefruit"? It's best to use words that are not related to a certain period in life. For instance, the phrase "driver's license" is more likely to prompt memories from when you were a specific age than the word "lamp." You can try the exercise opposite yourself.

Which memory comes to mind if I say:

Sunset:

Car:

Shoes:

Watch:

Fish:

Bag:

Raspberry:

Snow:

Notebook:

Candle:

When participants in studies are shown a series of cue words and asked about the memories they associate with those words, and then how old they were at the time of the memory, their responses will typically produce a curve with a characteristic shape: the reminiscence bump. Below is the result from one study undertaken with centenarians by Danish and American researchers. The reminiscence effect seems evident, as does the recency effect—this is the final upward flip in both curves. For example, when asked what memory comes to mind when cued with the word "book," what people have read recently may pop up more easily than what they read ten years ago.

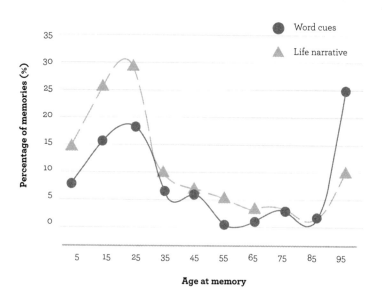

The percentage of life-story memories which occurred in each decade of life of centenarians using the life-story and the word-cue method.

Source: Pia Fromholt et al., "Life-narrative and Word-cued Autobiographical Memories in Centenarians: Comparisons with 80-year-old Control, Depressed and Dementia Groups," 2003.

The researchers used the cue-word method but also asked participants about their life stories. They found that, with the life-story method, an even larger share of memories goes into the reminiscence bump but the recency effect is reduced.

You can also see the reminiscence effect in some autobiographies, where adolescence and early adulthood are described over a disproportionate number of pages. For instance, if you look at Agatha Christie's autobiography, which is 544 pages long, the death of her mother happens on page 346, when Christie was thirty-three years old. So in the period that covers the reminiscence bump, memories fill more than ten pages per year. In contrast, Christie sums up the events of 1945 to 1965, when she was aged between fifty-five and seventy-five, in just twenty-three pages—a little over one page per year.

I am a victim of the reminiscence effect as well. If I compare what I remember from when I was twenty-one and thirty-one, it goes something like this:

I remember visiting the Ho Chi Minh Mausoleum in Hanoi on my twenty-first birthday. I remember wondering whether Bill Clinton, Tony Blair or Danish Prime Minister Paul Nyrup Rasmussen would one day have something similar built for them. This was in 1999.

I remember working as a gardener over the summer. I remember the smell of grass mixed with diesel when I cut the lawns and that the Red Hot Chili Peppers had just released *Californication*.

I remember visiting Paris. I remember reading *A Farewell to Arms* by Ernest Hemingway in the Jardin du Luxembourg. It was a hardback and the cover was brown and blue.

I remember meeting a girl from Seville. I remember spending the afternoon with her at the Musée d'Orsay. I remember that museums cause you to lean in and whisper and that I felt her breath on my ear. I remember that her name was America, that we walked across the Pont de Sully and that her lips tasted like Spanish ham.

I remember living for three months in Baeza, a small town in the mountains of Andalusia, roughly 100 kilometres north of Granada.

I remember my room in Hostal el Patio. One bed. One chair. One desk. I would buy bread and manchego cheese and use a bag outside the window as a fridge. I remember the two books I brought with me—*The Name of the Rose* by Umberto Eco and a book on the Danish philosopher

Søren Kierkegaard—and reading that "Life must be lived forwards, but understood backwards." Two books, a mixtape and a Walkman were my entertainment. I went for a lot of walks. I remember returning home one evening to find I had accidentally locked the door and having to climb up the drainpipe to get to the window of my room. I miscalculated where my room was and scared an old lady.

In the mornings, I would go to Café Mercantil and the waiter would shout, "*Un café con leche!*" when he saw me, and I'd sit in the corner of the café and write really bad literature in an A5 notebook which was black and grey. I remember writing the question: "Do we leave places, or does a place leave us?" Deep stuff. The coffee was 225 pesetas.

In the evenings, I would go to a bar called Caché, drink Four Roses whiskey with two ice cubes and flirt with the bartender, who was called Ventura. She wore a black leather jacket and had a dog called Chulo.

I remember working in a bakery back in Denmark. The shift was from 1:30 a.m. to 9 a.m. I remember the recipe to make 140 kilos of filling for the cinnamon buns: 70kg margarine, 5kg cinnamon . . .

I remember working at the harvest at the J. Marquette vineyard in Champagne. In the morning, Jacques Marquette would wake us workers with a loud *Bonjour!* in his deep voice. I remember there was a bell jar of cheese you could help yourself to for breakfast. There was a lot of cheese— strong cheese. I remember how you had to tip the bell jar just the right way so as not to unleash a tsunami of accumulated cheese odors. I remember working in the fields, small strips of land around the village. I remember how much my legs hurt. I remember that cutting myself with the secateurs was not so bad, but getting cut by the guy working on the other side of the vine was really bad. When you cut yourself, you stopped cutting when you felt the pain.

I remember the black grapes. I remember they had to be squeezed and the juice removed from the zest quickly so the wine would not take on the color. You could hold a cup under the press and drink the freshly squeezed juice. The best part of the day was returning from the fields, tired, dirty and hungry. In the evenings, we would have a rustic dinner. I remember there was a fridge stacked with only champagne. I remember ending the day with a perfect deep sleep on a thin mattress on a concrete floor. I remember being very happy.

I remember the smells, the sounds, the sights, the tastes and the physical sensations of my twenty-first year. I remember conversations, what I was thinking about, the price of a coffee, the names of dogs, the menus. I remember being twenty-one.

When I was thirty-one, I remember going to the office a lot.

In fact, the only exchange of words I remember from that year is a short conversation I had with Dr. Rajendra Pachauri, the chairman of the Intergovernmental Panel on Climate Change. This was the year of the climate summit in Copenhagen. The company I was working for was organizing an event at Kronborg Castle in Elsinore, north of Copenhagen, also known as Hamlet's Castle.

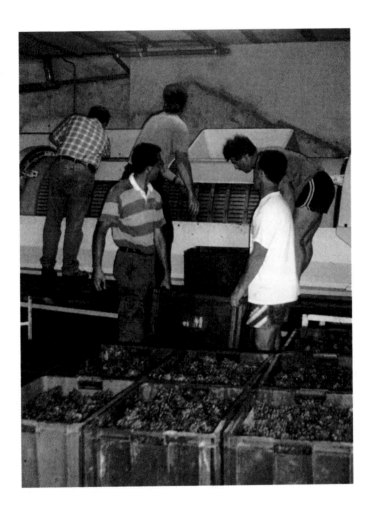

"Do you know where the bathroom is?" Dr. Pachauri asked me.

"I'll show you. It's in the courtyard. There's only one toilet in the entire castle."

"Hmm," he said. "Only one toilet in the entire castle—really?"

"Yes."

"Do you think maybe Hamlet was misquoted?"

"Why?"

"Maybe he said, 'To pee—or not to pee—that is the question.'"

That's it. That is pretty much all I remember from that year. Granted, it was witty—but is it really "life flashing before my eyes" material? There must have been more meaningful moments to hold onto and to make into memories than pee puns. Nevertheless, that is what remains.

That is the tyranny of the reminiscence bump.

What about you? What do you remember about being twenty-one? Or from another year? And how do your memories from different decades compare?

One theory behind the reminiscence bump is that our teens and early adulthood years are our defining years, our formative years. Our identity and sense of self is developing at that time and some studies suggest that experiences that are linked to who we see ourselves as are more frequently retold in explaining who we are and are therefore remembered better later in life.

Another theory is that the period involves a lot of firsts. Our first kiss, our first flat, our first job. As you might recall, the Happy Memory Study we conducted at the Happiness Research Institute found that 23 percent of people's memories were of novel or extraordinary experiences.

Novelty ensures durability when it comes to memory. Several studies show that we are better at remembering the novel and the new, the extraordinary days when we did something different. One study by British researchers Gillian Cohen and Dorothy Faulkner found that 73 percent of vivid memories were either first-time experiences or unique events. Extraordinary and novel experiences are subject to greater elaborative cognitive processing, which leads to better encoding of these memories. That is the power of firsts. Extraordinary days are memorable days.

HAPPY MEMORY TIP:
ONCE A YEAR, GO SOMEPLACE
YOU'VE NEVER BEEN BEFORE

Make plans to visit new places—be it an exotic
destination or the park across town.

I love going back to places I've been to before. Every summer, I go
to Bornholm, a small island in the Baltic Sea. I have a small place
there. I enjoy knowing where the wild cherries grow and where to go
spearfishing for flounders. But recently I have come to appreciate the
importance of going somewhere I have not been before, to make new
memories. To make the pace of time slow down when I look back ten
years from now. And going someplace new doesn't always have to
mean northwest Mongolia or Ouagadougou. It can also mean that
park at the other end of town.

Last year I went to the white cliff of Møn. The gigantic white cliff
rises over 100 metres high above the Baltic Sea and offers some of
Denmark's most dramatic scenery. (In all fairness, the competition is
not fierce in this pancake-flat country. The tallest point in Denmark
is 171 metres.) The cliff is also one of the best places in Denmark to
go fossil hunting. Often, fossils over 70 million years old—give or
take a few years—are found there, and recently a young boy found
a dinosaur tooth from a mosasaur, the T. Rex of the ocean. It takes
only an hour and forty minutes to drive there from where I live in
Copenhagen—yet I had never gone before. I spent the afternoon
looking for fossils and humming the theme tune from the Indiana
Jones movies. I didn't find any fossils but I came home with another
memory for the treasure trove.

Where will you go? We all have places we've been thinking about
visiting but have never got around to it. So where have you never
been before? It might be somewhere far away, or somewhere nearby.
Get out the calendar. Get out the maps.

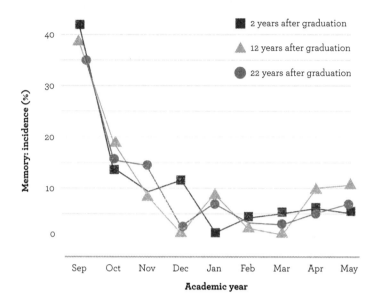

Source: David B. Pillemer et al., 'Very Long-Term Memories of the First Year in College', *Journal of Experimental Psychology: Learning, Memory and Cognition*, 1988.

The importance of first experiences also means that, say, if you go to university, you are more likely to remember events from the beginning of your first year than later in that same year. In a study led by David Pillemer, professor of psychology at the University of New Hampshire, participants were asked to describe memories from their freshman year in college. "We are not interested in any particular type of experience," said the researchers, "just describe the first memories that come to mind."

Researchers interviewed 182 women who had graduated two, twelve or twenty-two years ago from Wellesley College. In the second part of the study, participants were asked to analyze, one by one, each of the memories they had described earlier. The memories were rated on the intensity of the emotions the experience involved, the impact the event had had on their life both at the time of the memory and also in retrospect, and the estimated date of the experience they remembered.

The study showed that, for participants in all the university intake years, the majority of memories took place at the beginning of the academic year: around 40percent in the month of September and around 16 percent in October.

These results suggest that transitional and—as we shall see later—emotional experiences are especially likely to persist in the memory for many years. That is the power of firsts.

In the Happy Memory Study we conducted at the Happiness Research Institute, we also found evidence of the power of extraordinary days and novel experiences when it comes to happy memories.

More than 5 percent of all the happy memories we collected are explicitly about firsts. First dates, first kisses, first steps—or traveling alone to Italy at the age of sixty for the first time. The first job, the first dance performance or the first time you watched a movie in the cinema with your dad.

That is why I remember every first kiss I've ever had—including the very first. Her name was Kristy and I was sixteen and scared of her dad, who was a professional rugby player.

HAPPY MEMORY TIP:
CHASE MANGOES

New and memorable experiences also come in the form of food. Make sure you take your taste buds on trips, too.

I was sixteen when I first tasted a mango. It was in 1994, I was an exchange student in Australia, and mangoes had not yet been introduced to supermarkets in Denmark, where I grew up.

I remember the sweetness, the texture. I remember thinking, *Where have you been all my life?* Since then, I have been chasing mangoes—believing that there are still great food experiences out there which I have not yet had. I have tried fermented Icelandic shark, and snails in a street market in Morocco. Both made me throw up a little, but I remember those moments quite vividly. My point is that firsts need not come in the form of geography but can also be in the shape of gastronomy. If you want to create a night to remember for your dinner guests, then serving them something they have not tasted before might do the trick (but maybe not fermented shark, if you want them to come again).

Ideally, it would be something that is not over and done with in a second, like a shot of licorice vodka at three in the morning. Nobody remembers that—for several reasons. Better to go with something like an artichoke, which takes a bit of an effort to eat, as you have to peel each leaf off, dip it in salted butter then use your teeth to harvest that wonderful flesh. This makes the whole experience longer lasting and multisensory.

It might also be the reason why life seems to speed up as we get older. When we're in our teens, there are a lot of firsts, while firsts at fifty are rarer. The landscape of our youth may also change more rapidly. Compare Hanoi, Paris, Champagne or Baeza to a mash of days at the office.

This is also why studies find that people who immigrated from a Spanish-speaking country to the US have their reminiscence bump at different times, depending on how old they were at the time of the move.

Moving to another city is a personal temporal landmark, but landmarks also come in the form of universal or collective landmarks—like the Kennedy assassination, or 9/11.

In all circumstances, these temporal landmarks of firsts and changes of scene play an important role in organizing autobiographical memory. There is a before and an after.

If we want life to slow down, to make moments memorable and our lives unforgettable, we may want to remember to harness the power of firsts. In our daily routines, it's also an idea to consider how we can turn the ordinary into something more extraordinary in order to stretch the river of time. It may be little things. If you always eat in front of the television, it might make the day feel a little more extraordinary if you gather for a family dinner around a candlelit table—and if you are always eating candlelit dinners, it might be nice to eat dinner during a movie marathon.

THE HUMMINGBIRD

———

A couple of years ago, I spent the summer in Guadalajara, Mexico. I was finishing a book—and could work from anywhere—and there might have been a woman in the equation as well.

One afternoon, I was waiting outside a barbershop and, suddenly, a hummingbird appeared. It kept me company for a minute or two, hovering, flaunting its skills as the helicopter of the animal kingdom. *That's amazing. I have never seen a hummingbird before*, I thought.

A year later, my father, my brother and I were reminiscing about a trip we made to the States when I was twelve. Four weeks. Four states. Four different cars. We talked about New York, about the Grand Canyon, about the Kennedy Space Center and about crossing the Rio Grande from Texas to Mexico.

"Do you remember the hummingbirds?" my father asked.

"What?"

"The hummingbirds we saw in Utah?"

It turned out that the hummingbird I saw in Mexico was not the first. I had seen them many years before. The fact that I was twelve at the time might explain it. At that age, hummingbirds do not seem special. They are birds. And birds are not cool. You know what is cool? No, it's not a billion dollars—it is cherry Coke and MTV. Those are the special things my twelve-year-old brain stored.

Or, as Friedrich Nietzsche is supposed to have said, "The advantage of a bad memory is that one enjoys several times the same good things for the first time."

What may be ordinary and forgettable to you might be extraordinary and memorable to me. So, different people may remember different things about the same event. As a small exercise, try going for a walk with a friend or family member and compare afterwards what you noticed during it. If you have kids, you may also want to remind them of the extraordinary experiences you have shared together—they might not have realized at the time quite how remarkable they were.

Whale, horse, cat, eagle, cow, turkey, cheesecake, elephant

We remember the extraordinary things, the things that stick out. This is known as the isolation or von Restorff effect, after the German psychiatrist Hedwig von Restorff, who, in 1933, found that when participants are showed a list of words in which one word is very different from the others, that word is better remembered. For instance, in the list of words above, the word "cheesecake" will be the one you remember. And dropping the von Restorff effect into conversation also makes you sound smart at dinner parties.

HAPPY MEMORY TIP:
IF YOU ARE GIVING A TALK, TAKE A PINEAPPLE ON STAGE WITH YOU

If you want people to remember you, you need to give them something to remember you by.

About ten years ago, I got a scratch on my cornea from a dance-related accident which meant I had to wear an eyepatch for a week. Best. Week. Ever. At the time, I was working for a think tank called Monday Morning on sustainability. The eyepatch not only gave everyone carte blanche to make endless pirate jokes and allowed me to control every meeting I went to (Nobody disagrees with the patch!), it also made me less forgettable. Meik from Monday Morning? Is that the guy ... ? Yes, that's the guy with the eyepatch.

Maybe we all want to be remembered, to be thought about when we are gone. In *The Iliad*, Achilles considers the choice between a long and peaceful life and a short life that will bring him everlasting glory.

Either, if I stay here and fight beside the city of Trojans, my return home is gone, but my glory shall be everlasting; but if I return home to the beloved land of my fathers, the excellence of my glory is gone, but there will be a long life left for me, and my end in death will not come to me quickly.

Granted, we still read and talk about Achilles today, but maybe there is an easier way to be remembered than whooping ass at the gates of Troy.

So, if you want to be unforgettable, dare to be odd, to stand out. For instance, if I am doing a presentation at a conference, often I stand out easily because people remember "that happiness guy"—but what if I were just one out of twenty happiness researchers? The answer is: bring a pineapple with you on stage. When the conference is over the audience will remember the guy with the pineapple. Of course, you have to inform people why you brought it on stage; otherwise, it would just seem weird. Or weirder than you are going for. There's a fine line between good weird and never-being-invited-back weird. Bringing a pineapple to a meeting at the Prime Minister's office falls into the second category. By the way, good luck with trying to eat a pineapple again without remembering this point.

CHAPTER 11

MAKE IT MULTISENSORY

"Her name was Modesta, but she really wasn't," Lola said. Lola is my Spanish editor, and we were having a fish and squid lunch at the San Miguel market, just behind Plaza Mayor in Madrid.

Modesta means "modest" in Spanish; she was Lola's grandmother and she was one of those characters who would fit perfectly into a novel by Isabel Allende or a movie by Pedro Almodóvar. Whenever I think of her I imagine her with a proud stoic poise and a glance that could bring a horse carriage to an instant halt.

"If you go to university, you'll never be married," Modesta's father had warned her. This was Spain in the twenties and going to university was strictly for men. Furthermore, her father, despite being a doctor, believed that Modesta's sister had died because of the effect education could have on a woman's brain.

Nevertheless, Modesta persisted and did go to university. Her aunt would chaperone her, sitting at the back of the class knitting, watching Modesta and watching the boys. How's that for a scene, Almodóvar?

After school, Modesta and her aunt would go to La Mallorquina, a bakery on the Plaza del Sol established in 1894, and have small cakes known as *estrellas de hojaldre*.

Modesta graduated with three degrees, two in teaching and one in pharmaceuticals. Oh, and she did get married, and she survived the Spanish Civil War and lived to ninety-seven. In her later years she frequently asked Lola to bring her one of the *estrellas* from La Mallorquina.

La Mallorquina still exists today. A few months after learning Modesta's story, I was back in Madrid and went to the Plaza del Sol to find it. It is located right on the corner of Calle Mayor, opposite a KFC and a McDonald's. Unfortunately, they stopped making the *estrellas de hojaldre* a few years ago. "It was a very simple cake," the baker told me. "We have better cakes today."

But that wasn't the point, not for me. I was curious to taste what Modesta had tasted almost a century earlier, to experience a taste of her memory. Nor, I suppose, was the actual taste the point for Modesta. Sometimes, it isn't what the taste is like but what that taste reminds us of that is the attraction. Maybe what Modesta tasted was her youth. Maybe the taste was her aunt's knitting needles weaved into the professor's words on the laws of chemistry. Maybe it was a taste of freedom.

And Modesta is not alone in using taste as a memory trigger. In the Happy Memory Study we conducted at the Happiness Research Institute, people frequently mentioned the taste or smell of food. In fact, 62 percent of the memories we collected were multisensory.

Happy memories are . . .

"Walking down the main street in the town I grew up in with my mom while eating a lemon Italian ice cream."

"My mom roasting poblano peppers on the stove when I was a child. I loved the smell of it as the peppers' skin crackled and popped as they roasted in the flames."

"Eating s'mores [melted marshmallows and chocolate sandwiched between graham crackers] with my best friends and my cross-country teammates during my high school senior year—they were the best s'mores I ever had. We were sitting in front of the bonfire in the fall. The New England countryside is absolutely gorgeous. I thought I couldn't be happier at that moment, and I really feel like that is my happiest moment."

We are all aware of the journey a taste can trigger when it comes to memory. You taste the limoncello and instantly you are transported back to that summer in Italy and can sense the warm evening air on your skin. It is the feeling when past happiness is momentarily restored. We have all experienced tastes, sounds, smells, sights or a touch that sends us back there, a sensation that reminds you that you were once loved, that you were happy.

The link between our senses and our memory is a common theme in literature. Gabriel García Márquez opens *Love in the Age of Cholera* by stating that the scent of bitter almonds always reminded Dr. Juvenal Urbino of unrequited love. Our senses can trigger and retrieve memories. This is sometimes referred to as the "Proust phenomenon" or a "madeleine moment." *In Search of Lost Time* is considered Marcel Proust's most prominent work. Its seven volumes cover 3,000 pages. In the first volume, the character Marcel tastes a madeleine, dipped in tea, and memories from his childhood flood back to him:

> *She sent for one of those squat, plump little cakes called "petites madeleines," which look as though they had been moulded in the fluted valve of a scallop shell. And soon, mechanically, dispirited after a dreary day with the prospect of a depressing morrow, I raised to my lips a spoonful of the tea in which I had soaked a morsel of the cake. No sooner had the warm liquid mixed with the crumbs touched my palate than ... an exquisite pleasure invaded my senses ... Whence could it have come to me, this all-powerful joy?*

Several scholars have now pointed out that the original madeleine moment by Proust was in fact not what we now consider a madeleine moment. A madeleine moment is a spontaneous and vivid memory that is easily retrieved and triggered by a taste, but Marcel has to work hard to retrieve the memory and makes several attempts.

I know that Proust gets the credit for describing the link between taste and memory, but I think Winnie the Pooh said it best. He's discussing with Piglet the first thing they think of in the morning. Winnie the Pooh's first thought is *What's for breakfast?*, while Piglet thinks of what exciting things are going to happen that day. And Winnie the Pooh replies that that is the same thing. He understands that our experiences, our memories, are shaped by what we taste. See, no need to spend 3,000 pages on it!

Whether you pick Proust or Pooh as your prophet, the lesson here is to use all your senses to your advantage. Be aware of what you see, smell, hear and feel when you are happy.

A good example is given by one of the participants in the Happy Memory Study we conducted at the Happiness Research Institute, an American in his fifties.

> *We were in a house on a beach for six days in a row. I would get up in the dark early mornings to listen to the ocean roar and watch the warm sunrise. Later, I would walk with the woman of my life on the beach and birdwatch. After the walk, I would use my smartphone to submit birdwatching data to an international bird database while we had coffee together. The joy of seeing nature, hearing nature, touching the sand and helping bird science made this trip with the woman of my life very special. I remember because it was recent, and because it involved the loves of my life—nature, birdwatching and doing activities we both love with my partner. Also, by myself, staring into the darkness before sunrise and listening to the ocean cultivated profound inner peace, as did walking the beach.*

Take heed of this. Take it all in. This man notices all different types of sensory input: the sound of the roaring ocean, the sight of the birds in the sky and the warmth of the rising sun. Also, I think he really likes birdwatching.

HAPPY MEMORY TIP:
CREATE UNIQUE MEMORY TRIGGERS

You remember things by association—so make sure you place something in your experience that can take you back to this exact moment.

Even if we have not read about Proust's narrator's venture into a stream of consciousness set off by a madeleine dipped in tea, we may harness the power of Proustian moments.

The more of your senses—sight, smell, hearing, taste, touch—you can use, the more vividly you can remember; and the more cues you line up, the more likely it is that you can hold on to that memory and retrieve it.

Spontaneous memories are typically a result of associations. A detail from the memory is repeated, and that trigger activates the memory. The best triggers are those associations that are linked only to one memory.

If I smell coffee, I enjoy the aroma tremendously, but because I have smelled coffee so many times there is no single memory that is likely to be retrieved by me smelling it. On the other hand, if I smell dried seaweed, I will remember a beautiful day in July. I had been spearfishing and had caught three flounders and was sitting on a warm rock, looking out over the sea. My breathing was deep and I felt relaxed, at peace and happy. I wanted to hold on to that moment and store it. So I took a good whiff of a handful of dried seaweed to increase the odds of that happening.

So, next time you're really happy and want to capture the moment, take notice of the input from all your senses. Is there a unique scent, sound, texture or taste? Work that into your long-term memory.

INCENSE AND SENSE-ABILITY

When I visit London I usually stay at the same hotel.

There are two things that always strike me there. First, whatever room I stay in, there is a copy da Vinci's *Lady with an Ermine* hanging over the bed. An ermine is a ferret-like animal and this one looks quite ferocious, with red eyes and sharp claws, and I can't get over the fact that at one point in this hotel's history there was a meeting where someone said, "You know that painting with the creepy ermine? We should put that painting in *every* room."

The second thing that strikes me is the scent. Some hotels are perfumed with bespoke fragrances that are an integral part of their brand. One Swiss hotel chain wanted their guests to smell Switzerland so they had a unique fragrance made. Their signature scent has the smell of mountain air with a hint of money.

Companies like Air Aroma and ScentAir work with hotels and shops to create these scent-specific locations. One of ScentAir's clients is the M&M World store at Leicester Square in London. "What they sell comes pre-packaged," ScentAir UK's managing director Christopher Pratt said in an interview for the *Independent*, "so although it looked like the place should smell of chocolate, it didn't." It does now. Okay, you get the whiff of the idea.

But why does scent matter? It all comes down to creating a unique and multisensory experience that can be converted into memories for the guests or customers. "We're creating a lasting memory," explains Carly Fowler from Air Aroma. "Scent has the ability to directly influence how a hotel is perceived and remembered. From the moment guests arrive, they want to feel that their experience is special."

But the thing is, smells don't have any meaning prior to being associated with an experience. When a scent is experienced with something, that is what they become associated with and represent. We dislike the smell of rubbish because we know that it is the smell of rubbish. Or, to paraphrase Shakespeare's Hamlet: "There is nothing either good or bad, but thinking makes it so." Wait, what is that rotten smell? Okay, who the heck is having *sürströmming*? (Fermented herring smells so strong it has to be eaten outside.) I bet it's Uncle Claudius. There is something fishy about that guy.

DOES THIS MEMORY SMELL FUNNY TO YOU?

I think if Marie Kondo—the author of The Life-changing Magic of Tidying Up—*was a superhero, her archenemy could have been Andy Warhol. By the way, I think her superpower would be reuniting single socks.*

Warhol is best known for his cans of soup, his Marilyn Monroes and for coining the phrase "fifteen minutes of fame." Less well known is his habit of collecting. Between the early sixties and his death in 1987 he created over six hundred time capsules with hundreds of thousands of objects in them: an ashtray lifted from a fancy restaurant, Christmas wrapping paper, unopened letters, gallery invitations, a picture of Elvis, business cards, junk mail, fan letters, LPs, toenail clippings, dead ants, a lump of concrete and a "Do not disturb" sign from the Beverly Wilshire Hotel.

If I added some toenail clippings, I have drawers in my apartment that could qualify as time capsules, I guess. But people have been paying $10 to witness the opening of Warhol's time capsules at the Andy Warhol Museum in Pittsburgh. However, I think the most interesting of Warhol's collection projects was his Museum of Scent, or permanent smell collection.

Warhol had a passion for perfume. In his memoir, *The Philosophy of Andy Warhol (From A to B and Back Again)* (1975), he describes how he switched perfumes all the time to preserve memories attached to each scent.

> *If I've been wearing one perfume for three months, I force myself to give it up, even if I still feel like wearing it, so whenever I smell it again it will always remind me of those three months. I never go back to wearing it again; it becomes part of my permanent smell collection.*

Warhol believed that seeing, hearing, touching and tasting are not as powerful as smelling as aids to go back to a particular memory. By storing smells in bottles, he felt in control of his memories and would choose which memories to visit based on what mood he was in. "It's a neat way to reminisce," he said. One of the theories behind the importance of scent is that smell is linked to the limbic system in our brains, which is believed to be connected to memory and emotion.

Warhol was buried with a bottle of perfume called Beautiful by Estée Lauder. It has been described as "the fragrance of a thousand flowers." The top notes include rose, lily and mandarin, on a warm base of amber and sandalwood. It was launched in 1985. I wonder what happened that year that made him want to be buried with it.

Being buried with your favorite perfume may be a bit extravagant for some. When my time comes, I would like it kept simple. You know, just the standard bagpipes, gun salutes and five passing fighter jets. Also, my one-room apartment should have a minibar—gin and tonic and Oban whisky—and a replica of *Lady with an Ermine*.

HAPPY MEMORY TIP:
EVERY HAPPY MEMORY DESERVES A SOUNDTRACK

What comes to mind when you hear "Gangsta's Paradise" by Coolio, "Bailamos" by Enrique Iglesias or "White Flag" by Dido? They were in the charts in 1995, 1999 and 2004.

In 1995, I was working in a cinema and *Dangerous Minds,* starring Michelle Pfeiffer, was showing; in 1999, I was in Spain and every bar was "Bailamos" crazy; and in 2004, Dido was my go-to music when I was cycling around Copenhagen. So those are the scenes that occur in my mind's eye when those songs play. The smell of popcorn, the taste of whisky and the sight of the city on my commute at the time reappear.

Music can make us travel in time just as well as any scent. One note and we're taken back to that time, that place, that mood. You're right back there, as if you never left. As they say, behind every favorite song there is an untold story.

And the time-traveling aspect may shape our taste in music.

In 2018, Seth Stephens-Davidowitz, an economist and writer for *The New York Times*, explored data from Spotify. He examined every song that topped the charts from 1960 to 2000 and how frequently those songs were listened to by different people. No big surprise: age is a big determinant of our musical taste. Not a lot of men in their eighties have Taylor Swift's "Shake It Off" on their playlist. (Only policemen in their forties do. If you don't know what I'm talking about, you need to google it right now.) The study concluded that grown men and women stick with the music that captivated them in their earliest adolescence.

For instance, "Creep" by Radiohead is rather popular among men born in 1977. It is the 164th most-played song in that age group—but it is not in the top three hundred for people born in 1967 or 1987. "Creep" came out when the men who love it were about fifteen years old—and that seems to be the consistent pattern. Stephens-Davidowitz found that the songs most popular among men are those that were first released when they were between fifteen and sixteen years old; for women, the magic music age is between eleven and fifteen. So, if you loved the music as a teen, you will love it forever.

You may use that knowledge to know how to get the party started or to get people talking about their adolescent memories—or you may want to make sure your happiest moments have a soundtrack.

"That's the Way Love Goes"—Janet Jackson, 1993

Highest rank is among women aged 35 at the time (11 at song's release)

"Just Like Heaven"—The Cure, 1987

Highest rank is among women aged 41 at the time (11 at song's release)

"Oh, Pretty Woman"—Roy Orbison, 1964

Highest rank is among women aged 69 at the time (17 at song's release)

"Truly Madly Deeply"—Savage Garden, 1997

Highest rank is
among men aged
38 at the time
(18 at song's release)

"Crazy Love"—Van Morrison, 1970

Highest rank is
among men aged
63 at the time
(16 at song's release)

"I Can't Stop Loving You"—Ray Charles, 1962

Highest rank is
among men aged
72 at the time
(17 at song's release)

THE FALSE MEMORY DIET

Now, we know that our senses allow us to store and retrieve more vivid memories. A taste can trigger a memory. But our memories can also have an impact on which tastes we seek out, and this is true even for false memories.

Elizabeth Loftus is a professor at the University of California, Irvine, and she has conducted some fascinating studies on faulty memories and how they can influence our behavior.

The 2008 study "Asparagus, a Love Story—Healthier Eating Could be Just a False Memory Away" involved 231 subjects, who thought they were participating in a study on the relationship between personality and food preferences and completed a raft of surveys. One survey assessed their desire to eat each of the thirty-two separate dishes listed, including sautéed asparagus spears, and it was presented in the form of a regular menu, with appetizers, soups, and so on.

Another survey was about the cost of food and the participants' willingness to pay for twenty-one different food items, including rice, tortilla chips, courgette and asparagus at a grocery store.

These surveys were conducted several times and, over the course of their study, Loftus and her colleagues had planted the false memory that some of the participants loved to eat asparagus when they were children. Other participants were not manipulated into thinking this way; these formed the control group.

Relative to the control group, data taken from the participants who now believed they loved asparagus as kids demonstrated that these new (and false) memories had consequences, among them an increased general liking of asparagus, greater desire to eat asparagus in a restaurant and a willingness to pay more for asparagus in the grocery shop.

This study reminded me of a memory. When I was a kid, my friends, my mother and I used to pretend to be pirates and used celery sticks as rapiers. I don't like celery sticks, but I still buy them from time to time. You know—in case the pirates come back.

HAPPY MEMORY TIP:
CREATE A MEMORY DISH

If you enjoy cooking, you may want to link certain tastes or even dishes to happy memories.

This summer, my girlfriend and I created a "memory dish" after spending a wonderful day on the island of Bornholm, a day I wanted to remember. We had a slow breakfast with a side of crosswords and went swimming in the afternoon, alternating between the cool water of the Baltic Sea and warm rocks heated by the sun. Later, gin and tonics joined the party, which may explain why I forget what we had for dinner. But I remember that dessert was cherries eaten straight from the trees in the nearby forest.

We watched the light from the sunset by the water and walked back towards my cabin, only to notice that a new light was hovering over the horizon over Gudhjem (literal meaning, "God's home'), a charming small town on the eastern coast. The town has also given its name to the classic Danish *smørrebrød* Sol over Gudhjem (literal meaning, "sun over God's home'). Be careful pronouncing it in Danish—it can lead to irritable vowel syndrome.

The new light on the horizon was the moon rising. So, naturally, we called the new dish Moon over God's Home. It consists of a poached egg on smoked shrimp (a speciality of Bornholm) on toast. When you cut the poached egg on the dark shrimps, you can see the moon rise—and remember a perfect summer's day.

HAPPY MEMORY TIP:
THE MEMORY LANE WALKING TOUR

Visit places that can trigger memories of good times.

So, we know that being at the place where a certain event happened will make you remember it better. We use our sense of sight to be reminded of a memory. Armed with that fact, it makes good sense—and good fun—to go on a literal walk down memory lane.

Last summer, as I was researching this book, my girlfriend and I were visiting my dad, Wolf, and I had asked him to plan a "Tour de Wolf," a walk around Aarhus, the second-biggest city in Denmark. My dad had lived there in the sixties, when he was working in advertising, and moved back there some years ago.

"I want to see where you lived, where you worked and where you got drunk," I said.

That afternoon, we visited the places where he had worked. We walked his walk to work in the morning. We saw the Teater Bodega, where my dad and his colleagues would have dinner and a pint, the streets where the uniformed chauffeurs would wait outside the houses, shining the cars, and the chemist's where my mother worked when my parents first met. I remembered her telling stories about hating the leeches, and that she had to call her boss Her Apotekeren ("Mr. Pharmacist").

I had heard many of the stories before, but seeing the places where they took place made them come even more to life. And now some of the stories and memories of my father are integrated into the shared memory of a lovely summer afternoon walking around Aarhus. So go for a stroll down memory lane. Either your own or the lane of somebody you love.

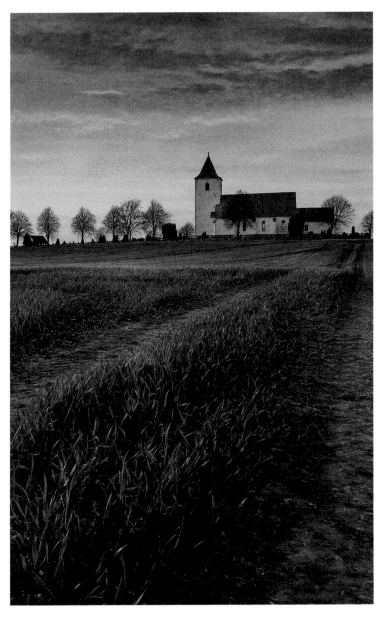

AMBASSADOR ON EGGS — THE POWER OF VISUALIZATION

Imagine you are invited to a dinner party at my place (we are having artichokes and calamari, by the way) and you meet some of my friends.

"This is Mikkel. He's a doctor and enjoys flying."

"Hello, nice to meet you, Mikkel."

"And this is Jess—he owns a clothes brand and is the best skier I know."

"Good to meet you, Jess."

"This is Lise. She's a journalist and plays soccer several times a week."

"Hi!"

"This is Jens. He's a lawyer and lives in Beijing."

"Ah, Beijing. Hi, Jens."

"And this is Ib. He works in IT and we play tennis twice a week."

"Hello, nice to meet you."

"This is Ida. She works in public relations and keeps bees."

"Wow—bees."

"And finally, this is Nikolaj. He counts money and has a fruit plantation on the Island of Fejø."

Now, can you remember the name of the first woman I introduced you to? Maybe not. You may in fact struggle to remember any of the names but have an easier time remembering their professions or hobbies.

This is known as the Baker–baker paradox. If we are introduced to someone named Mr. Baker, we are less likely to remember the name than we are to remember the profession if we are introduced to a baker. If someone is a baker, we can create an image of that person pouring flour, kneading the bread, wearing a tall white hat.

We have already formed a lot of associations with "a baker"—perhaps even multisensory experiences. We have smelled a bakery and eaten freshly baked bread. We can visualize what the baker does. The name Baker is just a bunch of letters. Names are essentially random syllables, a meaningless soup of sounds.

Perhaps, therefore, it is also easier to remember that Mikkel is a doctor and that Nikolaj owns a fruit plantation than the fact that Ib works in IT and Ida in public relations. It is easier to imagine Mikkel performing an operation or to visualize Nikolaj's apples trees than to form an image of what it looks like when Ida "does public relations."

Cicero, the Roman statesman, philosopher and orator, once wrote, "The keenest of all our senses is the sense of sight, and consequently perceptions received by the ears or from other sources can most easily be remembered if they are conveyed to our minds by the mediation of vision."

In the summer of 2016 I was in Kuala Lumpur for a presentation and was invited for a dinner with the Danish ambassador and his wife. I had begun researching memory at the time and the conversation fell upon that subject. We discussed how difficult it can be to remember names and how visualization can help.

Their surname is Ruge—which in Danish means "to hatch." In addition, I have two friends with the same first names as the ambassador and his wife—Nikolaj and Astrid—so it was an easy picture for me to create: my friends Nikolaj and Astrid sitting on top of some eggs. Because of that image, I still remember the name of the ambassador and his wife today—but I've forgotten other names I've heard more recently. That is just one small example of how visualization works and how superior our visual memory is to our verbal memory. This is something that has been explored by Lionel Standing, professor of psychology at Bishops University in Canada.

In 1973, Standing conducted a range of experiments exploring human memory. The participants were shown pictures or words and instructed to pay attention to them and try to memorize them for a test on memory. Each picture or word was shown once, for five seconds.

The words had been randomly selected from the Merriam-Webster dictionary and were printed on 35mm slides—words like "salad," "cotton," "reduce," "camouflage," "ton."

The pictures were taken from 1,000 snapshots—most of them from holidays—beaches, palm trees, sunsets—volunteered by the students and faculty at McMaster University in Ontario, Canada, where Standing taught at the time. But some of the pictures were more vivid—a crashed plane, for instance, or a dog holding a pipe. But remember: this was the seventies—all dogs smoked pipes back then.

Two days later the participants were shown a series of two snapshots or two words at a time, one from the stack of snapshots they had seen before and one new, and were asked which one looked more familiar.

The experiment showed that our picture memory is superior to our verbal memory. When the learning set is 1,000 words selected from the dictionary above, we remember 62 percent of them, while 77 percent of the 1,000 selected snapshots were remembered. The bigger the learning set, the smaller the recognition rate. So, for instance, if the learning set for pictures were increased to 10,000, the recognition rate dropped to 66 percent. However, we remember snapshots better than we do words. That may be why you might be better at remembering faces than names. So, if you are introduced to Penelope, it might help you remember her name if you picture Penelope Cruz standing next to her.

In addition, if more vivid pictures were presented, rather than the routine snapshots, recognition jumped to 88 percent for 1,000 pictures. The more bizarre the image—like my friends roosting on eggs—the more memorable it is. Again, the funnier, the naughtier or the more taboo filled, the more memorable. So keep that in mind when you picture Penelope Cruz standing next to the Penelope you have just met.

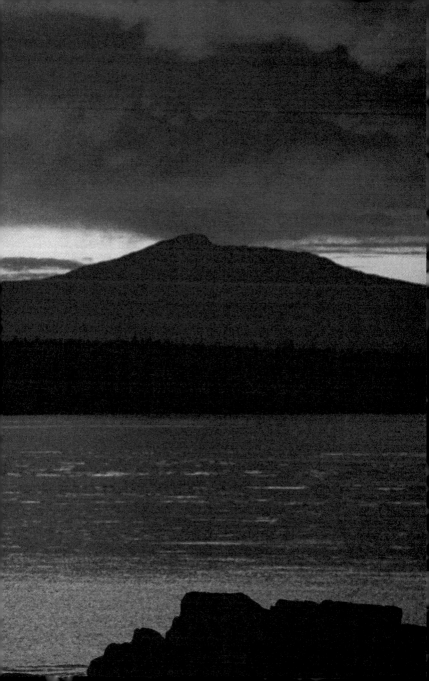

HAPPY MEMORY TIP:
DESCRIBE THE WHOLE SCENE

If you keep a diary, note down impressions from all your senses.

When I make deposits in my memory bank, I make sure to deposit the good ones so that, in the future, I'm more likely to make withdrawals of happiness. All our senses can take us back to the past—to a time and a place where we were happy—and they can work as triggers to do just that. So remember to include impressions from all your senses if you are keeping a diary.

Last year, I was lucky enough to spend a few days with my friends John and Millie. John is one of the editors of the World Happiness Report—but if there were a World Kindness Report, John and Millie would come top. These are two of the nicest people I have ever met. This is an entry from my diary. When you read it, remember the Chinese proverb ascribed to Confucius: "The palest ink is better than the best memory."

Every evening the deer come. Sometimes they come so close to the house and eat Millie's flowers on the porch. When the tide is low and the sun is out, seals warm themselves on the small reef and we can hear them from the house.

Hornby Island is on the West Coast in British Columbia. Three ferries and six hours from Vancouver.

Four generations of this family have come here. John's dad bought the land, and now John and Millie's children and grandchildren visit. John's dad donated a large piece of the land to the state to be used as a public park—now known as Helliwell Park—because "it was too beautiful not to share."

When the sun is out, it is warm enough to write outside on the porch. Across the water to the north, there are snow-covered mountain peaks, and when the wind blows I can feel the cool wind on my face.

I am working on the new book. I have no Wi-Fi here and the only distraction is the smell of strawberry jam or rhubarb tart which Millie is preparing. John is also writing—typing hard on the keyboard with two fingers. DAK—DAK—DAK.

Today, we've been hiking in the woods—it has a strong scent of what I think was Douglas fir—looking for eagles' nests, and Millie has been tending her garden—the biggest I've seen in a long time. She grows tomatoes, artichokes, bell peppers, raspberries, apples and pears, to name just a few. Everything is fenced to keep the deer out.

In the evening, we drink white wine and eat crab and asparagus and talk about Paris, politics and potato salad—and everything in between.

INVEST
ATTENTION

In A Study in Scarlet, *Sherlock Holmes tells Dr. Watson that he considers the human brain to be like an empty attic.*

He can stock it with the furniture of his choice, but there is limited space. So if one memory or piece of knowledge goes in, another one has to go out. In order to make room to remember what Holmes considers important information, for example how wounds made by different weapons look and how various poisons work, he gets rid of unimportant things such as the fact that the Earth revolves around the sun.

"You see, but you do not observe," Holmes lectures Watson in *A Scandal in Bohemia.*

> *"The distinction is clear. For example, you have frequently seen the steps which lead up from the hall to this room."*
>
> *"Frequently."*
>
> *"How often?"*
>
> *"Well, some hundreds of times."*
>
> *"Then how many are there?"*
>
> *"How many? I don't know."*
>
> *"Quite so! You have not observed. And yet you have seen. That is just my point. Now, I know that there are seventeen steps, because I have both seen and observed."*

Holmes highlights the important difference between seeing and observing when it comes to memory. Observing requires attention. We see lots of things that we don't register and can't recall. We observe when we register it and can recall it later. However, Holmes is not right when it comes to the limited space. Our memory is not a small attic but a large warehouse.

And going back to counting, I need you to go online for a minute. Google "Selective Attention Test"—and watch the video. You will be instructed to count how many times the players wearing white pass the basketball. Watch it—it takes about one minute—and come back.

Thanks for coming back. So, I guess the question is: Did you spot the gorilla? For those of you who didn't take the test, here's what happens. As I mentioned, you are asked to count the number of times the people wearing white in the video pass a basketball. There are three people wearing white, three people wearing black and two balls in play. The people in black pass one ball to each other and the people in white pass a second ball to each other. They all walk around each other, moving into gaps in the six-man crowd, passing the balls. You're counting the passes of the team in white, but around ten seconds in a person dressed in a full gorilla suit (let's just call him the gorilla from here on) walks in from the right of the screen. All the players continue to pass the ball as if nothing has happened. The gorilla walks slowly through the players, stops in the middle, beats its chest and walks out.

When I first watched the video, I knew what the experiment was really meant to demonstrate and I couldn't believe it when I read that more than half the time those watching and counting don't see the gorilla at all.

Even when participants are told about the gorilla in the video, they are convinced that there's no way such a ridiculous thing could have happened without them noticing. "A man in a gorilla suit pounding his chest?" they say. "Yeah, I would totally have noticed that." We are not only blind to the obvious but blind to our own blindness.

The video was made in 1999 by Daniel Simons and Christopher Chabris, both professors in psychology, at the University of Illinois and Union College, respectively. According to Simons, "Our intuition is that we will notice something that is that visible, that is that distinctive, and that intuition is consistently wrong." The point is, we are only taking in details from a tiny subset of the world we are experiencing. Other studies replicating the original study confirm the findings.

We are constantly bombarded by signals from our senses. At this moment, I am at a hotel breakfast in Tokyo. For the past hour, I have been focused on this page and I have been blocking out what has been happening around me—but as I try to be more conscious of my surroundings, I can smell the cooking from the omelette station nearby.

There are two Spanish businessmen at the next table discussing how much they can invoice their client. The music is upbeat and broken up by the noise of the cutlery being used by those guests not using chopsticks. From my table I can see the Tokyo skyline, with the Rainbow Bridge flashing lights every second. I've been sitting in the same position for a couple of hours and I notice that the chair is starting to hurt my legs. There are sights, smells, sounds, sensations, but in each one of my sensory systems there is a vast amount of input that is being processed and filtered.

The process is called selective filtering, or selective attention, and we do it all the time. We pay attention only to a small part of the information we receive and throw the rest away. As Sherlock Holmes would put it, we see but we do not observe. Everything that people recalled in the Happy Memory Study we conducted was something they had noticed, paid attention to, observed—that is why the ingredient of attention registered as 100 percent in the overview on page 10. It is perhaps less of an ingredient and more the baking tray—the very foundation.

It can be surprising how much of the world we see and yet do not take in. Not just the number of steps from the hall or chest-pounding gorillas in ball games but also how our food actually tastes, how the seasons are slowly changing or how the rain smells on a hot summer's day.

It may be a cliché to say you should stop and smell the roses, but research suggests it's good advice to increase your satisfaction with life. One study by professor of psychology Nancy Fagley at Rutgers University examined eight aspects of appreciation, including awe, or feeling a sense of connection to nature or life itself, and found it connected with happiness among the 250 participants.

But our attention is a currency. It is finite, a limited resource which we can allocate. *We pay* attention to something. Our attention is a coveted and lucrative market. And these days it seems that the most precious real estate is our eyes. While Netflix declares that sleep is their biggest competitor, marketing agencies are on the lookout for the last bits of our unharvested awareness.

Advertisements go up on the toilet door, the escalator handrail, the back of the school report card and in the seconds before you can type in your pin code at the ATM. Airlines show ads in the inflight movies—except if you travel business class. The ad-free experience is the new luxury good.

You are working on chopping down your to-do list, you check your phone, reply to Karen's message, check Facebook—aw, cute puppy video!—return to your to-do list, your phone pings, it's Karen, you reply that "Monday is fine," you open your calendar, remember the meeting you have on Monday and add "prepare presentation" to your to-do list. Sound familiar?

So what happens with our memory when our attention is being attacked by all these weapons of mass distraction and when we mass-multitask?

Well, first of all, there might not be such a thing as multitasking. We are not doing several things at once—we switch back and forth between several tasks and where we focus our attention.

One recent meta study published in 2018 in *Proceedings of the National Academy of Sciences* summarizes a decade of research done on the link between multitasking and cognition, including memory and attention ("Minds and Brains of Media Multitaskers: Current Findings and Future Directions" by Anthony D. Wagner, professor of psychology at Stanford University and director of the Stanford Memory Laboratory, and Melina R. Uncapher, assistant professor in the Department of Neurology at the University of California, San Francisco).

According to the meta study, across the literature the emerging trend is that people who multitask perform significantly worse on memory tasks. This, however, was not found in every study. Roughly half the studies examined showed no significant difference, but the other half showed that heavy multitaskers are significantly underperforming when it comes to attention and memory. In addition, not a single published study showed a positive effect on memory from multitasking.

We have no data on how often our hunter-gatherer ancestors were distracted. (The gatherers gathering data were not popular in the earliest tribes.) However, I believe one can argue that smartphones have become weapons of mass distraction in the past decade. In 2018, research from the UK's telecom regulator, Ofcom, cited in the *Guardian* showed that people are checking their smartphones every twelve minutes during their waking hours.

So yes, it seems plausible that we are less likely to remember—or at least pay attention—in the era of mass distraction.

THE HIPPO IN THE
DIRECTOR'S CHAIR

*We have one hippocampus on each side of our brain and
they are the parts of the limbic system that are concerned
with our emotions, behavior and long-term memory.*

You will find them above your ears, about 5 centimeters in. Look for
something that looks a bit like a seahorse.

The hippocampus plays a vital role in the consolidation of information
from your short-term to your long-term memory and in the retrieval of
memories. Your long-term memory is not *one* place in your brain, it is
distributed across several locations, but the hippocampus gathers all the
different bits that go into one memory. Think of it as the director that
re-creates the scene, using the actors, the lighting, the sounds, the script,
and so on. If you need a picture to remember this, just imagine a hippo in
a director's chair. The director receives input from other parts of the brain.
What were the sensory inputs of touch, sound, sight, taste and smell in
the memory? What did I feel about the whole thing? Here is where the
amygdala comes in. You have two, they are shaped like almonds and you
use them for decision-making, responses and the memory of emotions.
Was I scared or angry? The amygdala will let the hippocampus know
what the emotional significance of particular stimuli are and how you
felt. Different parts of the brain work seamlessly together to re-create a
memory: Quiet on set! Lights. Roll camera. Action!

Furthermore, the processes of remembering our past experiences and
imagining future ones are governed by the same part of the brain. Brain
scans show that thinking about the past and the future activate roughly
the same areas of the brain. Our memories shape our hopes and our
dreams for the future.

CONTEXT TRIGGERS — WHY WALKING THROUGH DOORS AFFECTS YOUR MEMORY

We've all been there: you're at home, sitting in front of your computer, you get up because you have to consult the letter on the kitchen table.

You go to the kitchen, only to stand there, not knowing why you came in. You open the fridge. No, that wasn't it. You go back to your computer—and remember. Oh yes, the letter.

This is a common short-term memory failure. It may not have to do with lack of attention but merely with the fact that you are walking through a doorway. The phenomenon of going into a room only to forget why you went in there is known as the "doorway effect."

In 2011, a team of psychologists at the University of Notre Dame in the US published the paper "Walking through Doorways Causes Forgetting." (No spoiler warning in academia, it seems. The team of researchers might have renamed *The Sixth Sense* "Boy sees dead people. Man realizes he is dead people.")

"Entering or exiting through a doorway serves as an "event boundary" in the mind, which separates episodes of activity and files them away," explained Gabriel Radvansky, one of the researchers behind the study, to *Live Science*.

In other words, the idea is that the act of walking through the doorway makes the brain believe that a new scene has begun and that there is no need for memories from the old scene.

In the study, Radvansky and his colleagues asked participants to play a video game in which they could move around, pick up objects and move them from one table to another. That was the task. When they were moving the objects, the objects were in their virtual backpack and thus invisible to the participants.

Sometimes the participants had to move the objects to a table in the same room and sometimes to a table in a different room (but the same distance away). In another version of the study, the participants were carrying real objects in shoe boxes (to keep them hidden) between actual tables in the lab. From time to time, the researchers asked the participants what they were carrying in their virtual backpack or shoe box.

The conclusion: the man had been dead the whole time and only the boy could see him—sorry, I mean, walking through doorways causes forgetting. Surprise!

In another experiment, conducted by Baddeley and Godden, both professors of psychology at the University of Sterling at the time, divers had to memorize a list of words in two different environments, one underwater and one on land. Underwater, the learning took place around 6 meters below the surface. They had to memorize thirty-eight unrelated words—one word every four seconds—which they heard twice during the learning stage (the divers underwater had a communication device).

Twenty-four hours later, the participants had to recall the words from the list either in the environment where they had learned it, or in the other context. What Godden and Baddeley found was that the list of words memorized underwater were best recalled underwater, and the lists of words learned on land were best recalled on land. Recall was approximately 50 percent better when the learning and recall context were the same.

It was only a small experiment, with eighteen divers, and was conducted in 1975. But we know today that our memory works better in certain contexts. Recall of memories is most effective when the conditions at the time of encoding—when the memory was made—match the conditions at the time of retrieval. That is why the police may bring a witness to the scene of the crime for an interview. This is known as "the encoding specificity principle," a term coined by Endel Tulving (yes—him again).

Tulving's theory emphasizes the importance of cues in retrieving and gaining access to episodic memories. We remember things by association. As a consequence, forgetting may be caused by a simple lack of appropriate cues that spark the memory.

The cue may be a memento or the mental state of the individual. But language also matters. Memories are better recalled when interviews are conducted in the language that was spoken when the memories took place. In one study, researchers interviewed bilingual participants in both English and Russian. When the participants were cued with Russian words, participants recalled memories that occurred in a Russian-speaking environment, and when presented with English cues they recalled memories that took place in an English-speaking environment. This underlines the importance of being in the right environment if you want to retrieve and hold on to happy memories. So you might want to revisit some of the scenes of the happiest times you have had.

HAPPY MEMORY TIP:
PAY ATTENTION TO WHERE YOU PAY YOUR ATTENTION

An evening or weekend of digital detox may make things more memorable.

In the Happy Memory Study we conducted at the Happiness Research Institute, several people mentioned experiences that had occurred when they were without power or an internet connection. One family experienced being without electricity one evening. They brought out candles and spent the evening telling their favorite family stories.

A thirty-year-old woman from the UK shared the following happy memory:

It was a bank holiday and so my boyfriend and I went away hiking for the long weekend, but there was a storm on the second day. We braved the rain in our waterproof hiking clothes for about three hours, then, wet and cold, we came back to our B&B and played Scrabble in the living room. It was just the two of us; it was very cosy, warm and dry. The wet hike was still pleasant, but this contrast made me feel relaxed and more rested. I love Scrabble as well, and we never play as we don't have it at home and, ordinarily, my boyfriend wouldn't want to play a board game. This time, there was nothing else to do on a stormy afternoon so it worked out well for me.

Being without our phones or without electricity can make us pay attention. With no phones and no TV, there are fewer sirens luring us in and grabbing our focus and we are more in control of where we place our attention. The Center for Humane Technology in the US has been pushing for realigning technology with humanity's best interests, advocating technology that protects our minds and design that aligns more with how we want to live. Here are some of their suggestions of how to live more intentionally with your devices:

1. **Turn off all notifications**
 Press. Me. Now. The red dots want your attention. Go to settings—remove all notifications.

2. **Go greyscale**
 Uh, shiny, bright colors! In the settings, you can adjust the digital candy to look less appetizing.

3. **Try keeping your home screen to tools only**
 Reserve your home screen for essential tools such as maps, camera and calendar. Move the attention grabbers off the first page or into folders.

4. **Launch other apps by typing it in**
 Search intentionally for the app you want to open instead of having it stare suggestively at you on the home screen.

5. **Send audio notes or call instead of texting**
 It is less stressful to say it than to type it. It is also a richer form of communication. The tone of your voice also gives valuable information.

As we shall see later, today we have great opportunities to outsource our memory to photographs. But, however convenient snapping pictures throughout our holidays might be, it may also mean that you are not paying attention. If you see something without attention, there is less of a chance that you will remember it.

MY STRUGGLE — WITH ATTENTION

"So what did you talk about?"

One rainy evening in Vancouver, I was sitting across from George Akerlof, an American professor of economics, talking about why we remember what we remember—and there was a lot to draw on. George was born in 1940. He remembered he was standing in the hallway when he heard the news that Bobby Kennedy had been shot. He remembered being teargassed at Berkeley during the Vietnam War demonstrations in '69. And he remembered meeting his wife.

They first met at a going-away party, but they didn't speak; the second time they met they were placed at the same table and spoke all night. So I was curious. "What did you talk about?" My expectations for the answer were high. George has a brilliant mind—and a Nobel Prize in Economics to prove it.

"I don't remember. The stuff you talk about when you meet somebody you like for the second time." George could probably sense my disappointment. "If I was a novelist, I could tell you." He said, "Karl Ove Knausgård could tell you." Karl Ove Knausgård is the Norwegian author who wrote the autobiographical books *My Struggle*. Six books: 3,600 pages.

"Yes, I remember reading three detailed pages about how he was washing potatoes one time," I said.

"You and I collapse the memory into one thing—but novelists remember every detail."

Maybe George was onto something; Hemingway once wrote that what made a good book was the accuracy of the details which made it believable.

"You're on the third floor, right?" I asked later. Akerlof and I were staying at the same hotel and had taken the elevator together before.

"No, I'm on five, you're on six."

If you're keeping score, that's Nobel laureate, 1; me, 0.

Since then, I have tried to collect more details from moments where I feel happy, moments I want to remember.

He had the lobster. I had the fish. I forget which. But it was delicious.

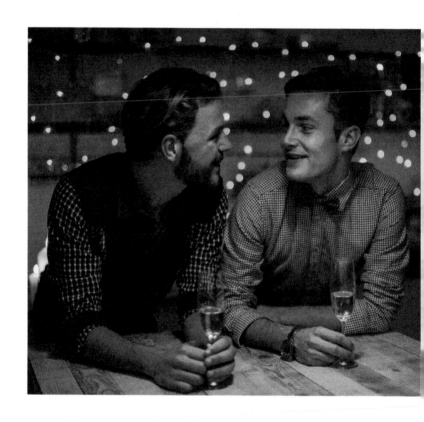

HAPPY MEMORY TIP:
TREAT HAPPY MEMORIES AS YOU WOULD YOUR DATE

Pay attention!

"The true art of memory," wrote Samuel Johnson, the British writer who compiled the *Dictionary of the English Language* in the eighteenth century, "is the art of attention."

Imagine you are out on a first date with someone. You are not just seeing, you are observing.

You notice the color of their eyes, the sound of their laugh—maybe even the scent of their perfume when you first said hello. You notice things like, when they get excited about a conversation, they use their hands a lot. You might even pick up on the subtle things like how their voice changes depending on the theme of the conversation, or how they slow dance in their chair if the food is especially good.

In other words, gorillas might be dining at the next table but you are paying full attention to your date. This is good. Let the gorillas have their romantic time on their own—you want to remember your happy moment. So harvest the details when you are making memories— the happy memories. Remember the hippo in the director's chair? You have to give it something to work with. So pay attention to the different elements that can go into the scene. What music is playing in the background? Or, if you were to describe the room in a novel, what would you write? Feed the hippo.

> *"The true art of memory is the art of attention."*

CHAPTER IV

CREATE MEANINGFUL MOMENTS

We remember when we pay attention—and we pay attention when we are present, engaged, committed, when what we see and process is meaningful to us.

As we saw in the last chapter, just being exposed to something does not mean we will remember it. If it is not important—not meaningful to us—we are less likely to notice it, process it, encode it, store it.

If you don't believe me, then tell me how many horizontal lines there are on your right palm. You have probably seen your palm many times but have failed to notice and then recall how many horizontal lines there are on it. That is a good thing, because the number of lines on your right palm is not meaningful, important information.

You seldom introduce yourself with "Hi. My name is Sandra. I have three horizontal lines on my right palm." If you do, then I have to make an important phone call and you'll have to excuse me for a minute.

But if you are into reading palms and believe that, according to chiromancy, a long and curvy heart line (the top one) means that you are good at expressing your emotions, then you might remember how your palm looks. If those lines were meaningful to us, we would pay attention to them and remember them.

THE BIG DAYS

Many of us are familiar with the daily grind, with routine: wake up, eat breakfast, commute to work, work, commute home, eat dinner, watch Netflix, go to bed, repeat.

It's easy to lose track of those days. What people remember are the big days in their life: the milestones we pass, the moments where we experience a sense of meaning, a sense of connection with our loved ones, with the world and with life itself. In the Happy Memory Study, 37 percent of the memories we analyzed were meaningful, for example, "the day I got married," "walking on the beach with my husband on a trip to celebrate our anniversary," "the birth of my son," "going to the beach with my grandfather on a Saturday morning," "a thank-you letter from my daughter," "having my son (adopted), our first trip, taking him home 200 kilometers on the highway on a snowy winter afternoon." Our collection of happy memories is packed with life's "big" moments.

One of the most touching memories came from a woman in her forties who thought back more than a decade ago to her grandmother's memorial service. She was walking hand in hand with her niece on a beach. It was one of those rare but gorgeous winter days. "There I was with my beloved tiny niece, who was the most precious person to me in the world, and I just felt so alive and grateful to have known my granny, and there we were, treading on, my niece and I, the next generations moving forth into the world."

These meaningful moments are also the ones held by the wealthiest 1 percent—the wealthiest of the wealthy—at least in Denmark. Last year, Michael Birkjær, one of my awesome colleagues, was invited to speak to the top earners in Denmark and conducted a small survey among them. Their happiest days were about connecting with people, about loved ones, about making sense of it all.

THE CONNECTIONS

There is no doubt that some of our most meaningful and memorable moments are when we connect with other people.

And it does not have to be the big days, the weddings and births. It can also be the connections we form on a daily basis. The tiny moments which may go unnoticed or seem insignificant to others can be those moments that never leave us, those moments when the small things in life turn out to be the big things in life.

"The moment my daughter looked up to me to say, "I'm so happy," for the first time."

"This morning, feeling my husband coming to bed and spooning me from behind, very tightly. Then our dog joining us and licking us both."

"We were four friends playing in the streets in Bogotá, Colombia. Afterwards, when we were tired of playing, we shared one Coke and some bread."

"My colleagues decorated my workspace because they knew I was having a hard time and it would cheer me up."

These thousands of moments shape our common stories. These moments are the atoms of our relationships. The thing you notice when you read or listen to people's happy memories is how often people play a part in them—many people: grandfathers, nephews, friends, daughters, parents, boyfriends, aunts, uncles, cousins, nieces, sons, sisters, mothers, grandmothers, husbands and wives.

Our loved ones seem to be the ones we remember best and we search to hold happy memories of them.

Happy memories of times spent with other people give us comfort. That is why, when we feel lonely, we are more prone to be nostalgic.

Earlier, I mentioned that there is a growing body of evidence that nostalgia produces positive feelings, boosts our self-esteem and our sense of being loved, while reducing negative feelings such as loneliness and meaninglessness.

Researchers at Southampton University created an experiment where the participants were asked to read stories either about sad events (like the 2004 tsunami) or happy events (the birth of a polar bear) to put them into either a negative or a positive mood. The researchers found that a negative mood is more likely to cause nostalgia than a positive mood.

In addition, the researchers asked the participants to fill in a personality test, but the researchers had skewed the questions so that their answers would make the participants believe that they were scoring high on loneliness. The study showed that those participants who had been put into a negative mood—because of the negative stories or the personality test demonstrating their loneliness—were more likely to engage in nostalgia, to look back on times when they were happy and surrounded by loved ones. This strategy of mood regulation worked, as they subsequently reported feeling less sad and lonely.

In the study we conducted at the Happiness Research Institute we found stories which support this. One woman in her twenties told us about a happy memory which had taken place a few years ago. She had been bundled up with a group of high school friends on a frozen lake with a flask of hot chocolate, telling stories and trying to open a bottle of wine with a sports shoe.

Sounds like a fun night indeed. When she answered the follow-up question of why she thought she remembered that event, she told us that she likes invoking that feeling of coziness, and that she misses being close to more people, as she was then. And she is not alone in having nostalgic memories. In our Happy Memory Study, we received both heartwarming and heartbreaking stories, stories of love and stories of lost love.

Sometimes happy memories can feel bittersweet. The classic 1942 film *Casablanca*, starring Humphrey Bogart and Ingrid Bergman, is a perfect example of the bittersweetness of memory.

Ilsa and Rick are lovers in Paris at the outbreak of the Second World War. Ilsa believes that her husband, Laszlo, a key figure in the Resistance, has been killed. When the Nazis invade France, Rick and Ilsa plan to escape on a train together and Rick intends to marry Ilsa on that train, but Ilsa doesn't join him, as she discovers that Laszlo is still alive and leaves Rick abruptly, without explanation. Their love affair is over. Later, Ilsa and Laszlo turn up in Rick's bar in Morocco and Rick and Ilsa's memories of their time in Paris resurface.

In the final scene, Rick has accepted that he and Ilsa will never be reunited—there are more important things going on in the world—and Rick tells Ilsa, "We will always have Paris." They will never have each other, but they will always have their memories of Paris. It was a great love, but it is gone. That's nostalgia in a nutshell. It may help and hurt at the same time, but we own it and nobody can take it away from us.

So happy memories can be bittersweet, but they also assure us that we are valued as people, that we have deep connections with other people and that we have led a meaningful life.

However, when it comes to happy memories, the importance of connection includes more than other people. Connecting with nature, connecting with our bodies and connecting with the world are also common denominators when we examine people's happy memories.

It could be skinny-dipping in a lake in Finland, playing in the snow in Scotland or hiking up Table Mountain in Cape Town. It could be watching the sun set or watching it rise, or watching the snow fall in the Alps. It could be trekking or surfing or running barefoot in the grass, or sitting on a pebbly beach or on top of Mount Kanchenjunga, watching the world down below. It could be a snowbike ride with our son in Newfoundland or standing on a quiet beach in Pembrokeshire with a friend. It could be horseback riding or dog walking or seeing a blue whale in the Arctic. In short, happy memories are what make life magical and meaningful.

One Danish woman in her late twenties recalled an event when she was twelve. One summer afternoon, she was lying in the long grass in a meadow.

My family and I had been attending an outdoor field trip with my younger sister's school class. It had ended a little earlier, and people had left. My sister was lying next to me and we were looking up into the clear blue sky, chatting. It was the purest feeling of happiness. The warmth from the late-afternoon sun, the feeling of being so close to nature as I lay in the grass, the connection I felt to my sister and the contrast of the event that had just ended (with so many people, a lot of chatter and lots of things going on) to the calm and intimate feeling of just me and my sister being there after everyone else had gone.

THE MILESTONES

Our happy memories are populated by our loved ones and we experience meaning when we connect with others and with the world, but we also experience it when we feel that we are reaching our potential or an important milestone or goal. Happy memories are moments when we became what we dreamed we could be.

"Succeeding in a very difficult exam."

"Finishing my first marathon in October 2016."

"My acceptance into university."

"Hitting a perfect forehand in tennis last week."

When you read people's memories, you can sense their pride. When you read people's memories, you can hear the echo of their triumphs. When you read people's memories, you learn about their hopes and their dreams.

The mountains they climbed, the marathons they ran, the letters of acceptance they opened and the big deals they closed—these are the memorable moments, the ones that were meaningful to us.

They are the young Iraqi man who remembers being eleven and buying a toy with his own money.

They are the woman who remembers finally receiving her university degree at the age of thirty-eight. They are the man who started his own company, put in a proposal for a big project with his heart in his mouth and won the project.

They are the young person who remembers starting testosterone treatment when transitioning to become a man and a grandmother who finally fulfilled her life-long dream of having a motorcycle.

These are the important moments that make up our life's narrative. We remember the defining moments in our lives, the moments that made us who we are, the moments where we became who we hoped we could be.

As a happiness researcher, I have observed that happiness is often found when three views align: who we feel we are, who we want to be and how others see us. When our loved ones see us and love us for who we really are, and when we manage to become who we know we can be, that is where we find happiness.

WHAT DOES THE MEANING OF LIFE MEAN?

How do you measure happiness? What is the good life? When you tell people you work in happiness research, they ask a lot of questions.

Happiness surveys often explore meaning or a sense of purpose. In fact, it is such an integral part of the good life that the UK Office of National Statistics dedicates one of the four questions in its annual well-being survey to it: "Overall, to what extent do you feel the things you do in your life are worthwhile?" The three other questions cover overall satisfaction with life and the level of happiness and anxiety people felt the day before.

There is a connection between all four. A great sense of meaning in life goes hand in hand with overall life satisfaction and how happy you felt a day ago.

Other surveys take a deeper look at meaning and ask whether you feel your social relationships are supportive and rewarding, whether you feel engaged and interested in your daily activities, and whether you feel competent and capable in the activities that are important to you.

To me, the good life—a full life, a rich life—is a life both of purpose and pleasure. It is when life offers satisfaction with the present, hopes for the future and peace with the past. Happiness is not a one-ingredient dish.

HANNAH AND HER SISTERS— A VERY SIMPLIFIED VIEW OF HOW MEMORY WORKS

Memory is our ability to encode, store and recall information.

The processes involved in memory are encoding ("This is Hannah, my sister'), storage and consolidation (Hannah is Bob's sister) and recall ("Hi, Hannah. Nice to see you again').

We first experience the world through our senses. When you meet someone new, you may register the color of their eyes, the sound of their voice, the scent of their perfume and the firmness of their handshake. This is the first part of the encoding phase of a potential memory.

All these sensations are combined into one single experience and analyzed before our brain decides whether the information should be committed to long-term memory. Different factors have an impact on this. For instance, as we saw earlier, paying attention increases the chance that we will remember the experience. And, as we will see in the next chapter, emotion makes the experience more intense and tends to increase how much attention we pay to an experience.

A potential memory starts off in short-term storage—our short-term memory. This is also known as the working memory, and it's our limited and temporary memory storage facility. Think of it as being like computer RAM. It focuses our attention on the sensory input and holds it long enough so that we can solve the problem at hand and react to the sensory input. "Hi, Hannah" (eye contact, smile, firm handshake—"Well done, brain.")

We can hold on average seven (plus or minus two) chunks of information for up to twenty or thirty seconds at a time. That is why you are likely to remember phone numbers but less likely to remember your credit-card number. This was first documented in 1956 by George Miller, a psychologist at Harvard University, in the paper "The Magical Number 7, Plus or Minus 2," so it is sometimes referred to as Miller's Law.

"Oh, and let me introduce you to Hannah's six sisters."

"Great."

"And their spouses."

"%&€###!"

We can apply different memory strategies to remember what we need to remember for long enough—for instance, by repeating the number and thereby resetting the short-term memory clock over and over, or dividing the numbers into chunks, for example, 18006169335 becomes 1-800-616-9335.

According to Miller, it is the chunks of *meaningful* information that represent the limit. So, you would probably have trouble remembering the twenty-two letters CIANHSNASABBCFBISOKMTV, but you would probably have a better chance of remembering that Hannah and her sisters work at CIA, NHS, NASA, BBC, FBI, SOK, and MTV. But these chunks also depend on the knowledge of the individual person trying to remember. That is why you would have more trouble remembering SOK than I would: it's the Danish Navy Operative Command (Søværnets Operative Kommando).

While encoding usually describes the processes that happen *during* the experience of an event, consolidation usually describes the processes that happen *after* an event has taken place—this means keeping a memory after you first acquired it.

The more important the information is, the bigger the likelihood that you will transfer the information to your long-term memory. Is it the name of a person you will never see again, or do you think you might just have been introduced to the love of your life? ("By the way, this is Hannah's colleague. I've been meaning to introduce you two for a long time—you have so much in common.")

So, the important experiences—the first time we met our future spouse, our wedding, when two became three, and so on—are more likely to be transferred to our long-term memory, and this is why we see an abundance of important and meaningful events in our Happy Memory Study.

If we have encoded and stored information or an event, we have the opportunity to recall or retrieve it. A memory is only a memory when you remember it. It's kind of like Santa: if nobody thinks of him, he ceases to exist.

The more you think about a memory, the more likely it is to be remembered. And we are more inclined to think about experiences that were important and meaningful to us. Our memories are essentially connections between neurons in the brain. In order to keep those connections intact, they have to be exercised or activated regularly. Retrieval is therefore one of the best ways you can strengthen a memory. In that way, memory is like a muscle.

"Wait, didn't you just say that memory is like Santa?" you ask. "So which is it? Like Santa, or like a muscle?" It's a muscular Santa, okay? Santa on steroids. I mean, he works one day a year. The elves are doing all the hard labor in the toy factory. Maybe he checks in for status meetings once a week. What did you think he would do with all that leisure time? He's going to spend it getting ripped. In fact, Santa is so ripped he was offered the role of Magic Mike in the movie, but he couldn't take the part because there was a clause in his contract. Anyways, ripped Santa. There's an image for your memory bank.

HAPPY MEMORY TIP:
MAKE AND CELEBRATE MORE MILESTONES

Bring out the notebook, then bring out the bottles.

One of my favorite movies, besides *Indiana Jones and the Last Crusade*, is *Breakfast at Tiffany's*. If you don't know it, the movie is based on a novella by Truman Capote and tells the story of a romance between Holly Golightly, gold digger and diamond enthusiast (played by Audrey Hepburn), and Paul Varjak, struggling writer and paid boyfriend (played by George Peppard).

One morning, Paul shares with Holly the news that he's had a story published. She wants to celebrate and asks him to open a bottle of champagne before breakfast. Paul has never had champagne before breakfast before so Holly suggests that they should spend the day doing things they've never done before. (Well done, Miss Golightly— straight out of the Power of Firsts playbook.) Later that day, Holly and Paul go to the main branch of the New York Public Library, where Holly has never been, and Paul autographs a copy of his book, *Nine Lives*.

The film is a classic. It is heartwarming. It has Audrey Hepburn in it. And throughout the movie the music of Henry Mancini flows— including the iconic "Moon River." So what's not to like?

Ever since I first saw the movie I've wanted to pull a Paul Varjak, so it's been a long-term goal for me to sign my own book at the New York Public Library. So, last year, I found my book there, on the corner of 5th Avenue and 42nd Street, and signed it. Now when I watch the movie I'm taken back to that wonderful day in New York and to something that was a meaningful milestone for me.

Start planning which milestones you would like to celebrate. They may be big or small, for example walking ten thousand steps each day for a month or finishing renovating the kitchen or finding a new job. Make sure you also note down how you're going to celebrate them. Will you go out for a nice dinner or allow yourself to stay at home the entire weekend watching your favorite films?

Last year, I bought two bottles of bubbly for each employee at the Happiness Research Institute and asked them to write down which milestones they would have to pass in order to open them. So far, we have toasted weddings, finished reports and surpassing our archenemy think tank in terms of followers on social media.

CHAPTER V

USE THE EMOTIONAL HIGHLIGHTER PEN

*On September 6, 2017 I was sitting in the Green Room of
the* This Morning *television show in London, waiting to talk
about my most recent book.*

I was nervous. The show has almost as many viewers as I have fellow
countrymen—and it was live. My wonderful publicist, Julia, was there to
help me prepare. I forget what she said precisely, but I remember that,
between the lines, she pleaded: "Don't screw this up, Meik."

Spoiler alert: I did.

The interview started out fine, but as we were drawing to an end, Phil,
one of the hosts of the show, asked, "So you have written *The Little Book
of Hygge*, and now *The Little Book of Lykke*—what are you going to do
next?" I thought the way he pronounced the Danish words *hygge* and *lykke*
was very good and I wanted to compliment him. I also knew that a lot of
people in the UK had been watching Danish dramas such as *Borgen*, *The
Bridge* and *The Killing* and hearing them in the original language, so I
thought that could explain why Phil's Danish was so good. "Well done on
your pronunciation of Danish," I said. "You must have been watching a lot
of *Danish Borgen*." He heard a completely different word and started to
laugh and blush, along with the other hosts. I had no idea why they were
laughing. "What did he say?" asked Holly, the other host. "I'm afraid to
ask," said Phil. End of interview.

Later that day, when I read an article with the title "Host Mishears Danish Guest" I was reminded that, in the UK, people pronounce it *Bor-gen*, with two syllables, but in Danish it is pronounced differently and Phil had heard, "You must have been watching a lot of Danish porn." When I realized what the hosts thought I had said, I wanted to find a very small hole to hide in. I often think about it. Every time I have to do a live interview, I think to myself, *Well, it can't be any worse than me talking about porn.* We all have these palms-to-face experiences, ones we still haven't got over even years later. They pop up in our memory when we least expect them and when we least want them to.

The reason for their stickiness is that emotions act like a highlighter pen, for example, the embarrassment I felt after my live TV faux pas. Emotional reactions such as fear or embarrassment are processed in the amygdala (the part of your brain where the fight-or-flight response also begins), allowing you to learn the aspects of the situation that are relevant to the emotions you experience. So now when the lights go on in live TV interviews, I remember to steer clear of talking about Danish TV shows.

An emotional reaction will make experiences and moments more memorable, so the art of making memories means making the emotional highlighter pen work for you.

In the Happy Memory Study we conducted at the Happiness Research Institute, 56 percent of the memories could be labeled as emotional experiences: children being born, people getting married, first kisses.

"One of my happiest memories is the day my husband and I got married," wrote a young woman from the US. "I had just graduated from college, and we were getting ready to follow our dream to move west. We didn't have a lot of money at the time, and neither of our families helped us pay for the wedding, so it was very small. We only spent around $300 for everything. We got married in the gardens of the art museum where we had one of our first dates. We wrote our own vows and, during the ceremony, white flowers from the trees began to fall all around us. We couldn't have asked for a more perfect day. There was beauty in its simplicity because we focused on what was important (marrying each other!) rather than getting caught up in making it extravagant."

This is also why we remember first kisses. You probably have a quite vivid memory of your first kiss. Where it took place. What you were doing in the minutes or hours leading up to it. Whether you locked eyes before and knew the kiss was coming or whether it took you by surprise. Days when we are emotional might be some of our happiest days—but emotional days might also be some of our unhappiest. We all have sad and painful memories, and some of them are unique to us and some of them we share with the world.

HAPPY DAYS ACCORDING TO TWITTER

So what happens on days when people are happy or unhappy? One way to answer that question is to use the Hedonometer.

It's based on research by Peter Dodds and Chris Danforth, both professors in math, and their team at the Computational Story Lab at the University of Vermont.

The Hedonometer is based on people's online expressions and uses Twitter as a source. Roughly ten thousand words have been given a happiness score from 1 to 9; 1 for very sad and 9 for extremely happy. For instance, "love" has a score of 8.42, "cried" 2.2, "disappointed" 2.26, "butterflies" 7.92 and "memories" 7.08.

The Hedonometer tool takes a daily sample of 50 million tweets and assigns a happiness score for the day based on the language used in those tweets. To some extent, you could say it is the emotional temperature of the world (of Twitter users, at least). Data has been collected since 2009.

Low points are terrorist attacks and the death of celebrities, while peaks cluster around Christmas, Thanksgiving and Mother's Day. Some days call for happiness and some call for sadness—but the common denominator is that we are more likely to remember emotional days—at either end of the spectrum.

Here's a sample:

Monday, December 25, 2017
Christmas Day
Average happiness: 6.25

Sunday, May 11, 2014
Mother's Day
Average happiness: 6.14

Friday, April 29, 2011
wedding of Prince William and Kate Middleton
Average happiness: 6.08

Sunday, June 15, 2014
Father's Day
Average happiness: 6.07

Monday, May 24, 2010
the TV show *Lost* aired its final episode the night before
Average happiness: 6.03

Tuesday, August 12, 2014
death of actor and comedian Robin Williams
Average happiness: 6

Wednesday, November 9, 2016
election of Donald Trump as the 45th President
of the United States
Average happiness: 5.87

I think this is a fun tool, but I think it has shortcomings when it comes to a deeper dive into an individual's experience of their happiness. Some things check out. Monday has a lower happiness score than Friday. But is "gravy" (6.32) really a sadder word than "sandwich" (7.06)? I think that's quite a controversial scientific standpoint. Nevertheless, the Hedonometer may also point us to dates where people create the strongest memories.

A FLASH OF REMEMBRANCE

You probably remember quite vividly where you were when you witnessed 9/11. Or when you heard about the death of Princess Diana, or saw the first Moon landing, or the fall of the Berlin Wall, for that matter.

They are all likely to be a flashbulb memory if you witnessed them in your lifetime. A flashbulb memory is a snapshot of a moment in time when an important event took place; the term was coined by Harvard psychologists Roger Brown and James Kulik in 1977. They believed that when important events happen they are stored in a vivid and detailed way so we can access the memory later on, analyze the experience and perhaps avoid similar events in the future, if the experience was dangerous.

We often speak of flashbulb memories as national or international events but one study conducted with American university students showed that only 3 percent of their flashbulb memories were such events. The vast majority were personal events. First kisses. Exams. Broken legs.

Happy events as well as dangerous or traumatic ones are stored as flashbulb memories. In one study exploring flashbulb memories related to the Second World War in Denmark, Dorthe Berntsen and Dorthe K. Thomsen, both professors of psychology at Aarhus University, examined the memories of the reception of the sad news of the Nazi occupation of Denmark in April 1940 and the happy news of the liberation on May 4, 1945. One hundred and forty-five Danes between the ages of seventy-two and eighty-nine were interviewed and their answers were corroborated against objective records—for instance, the weather reports or which day of the week the occupation began. The liberation was broadcast on Radio London, around half past eight in the evening.

One woman recalls:

> *I had been to Tivoli and had met up with a friend from school. We were anticipating that a surrender could happen soon and wanted to go home and listen to the radio from England. But we only made it to Monasvej, when a man came out from restaurant Bastholm and yelled, his arms swinging, "Children, Denmark is free!" I remember that episode as if it was yesterday.*

Ninety-six percent of the participants remembered when they first heard about the German capitulation. Interestingly, a subsample of the participants had reported ties to the Resistance movement in Denmark, and they had more vivid, detailed and accurate memories than did participants without such ties. I imagine the people in the Resistance movement were more emotionally invested and thus have a stronger memory of the German capitulation. This phenomenon is also demonstrated by other studies. The closer our ties are to the event, the better we remember it.

One study looked at the flashbulb memory of the news of the resignation of Margaret Thatcher among British and non-British people. One year after the British Prime Minister had stepped down, the British participants' memory of the event was still vivid and accurate, in contrast to the non-British participants, whose memories had faded and who were more prone to reconstructing erroneous versions of the event. The same effect has been found for the details concerning the death of Princess Diana, where people in Britain had a more accurate memory of the events than people in other countries. In addition, the assassination attempts on President Ronald Reagan and Pope John Paul II took place within a few months of each other. However, when asked when they happened, Americans think that the attempted assassination of President Reagan was more recent, while Catholics believe the incident involving the Pope was more recent.

The events in the study above are sad ones, but the same mechanism also works for happy events. You might feel that your wedding was more recent than your friend's do. It is the vividness and level of detail in our flashbulb memories that often make us believe that the events took place not as long ago as they actually did.

So what can we take away from this when it comes to how to make memories? Is the lesson here that we should join the Resistance in case of a Nazi invasion? Well, yes—that, too—but also that, if we want to make memories, we should consider using the emotional highlighter pen. When we have days when we have experienced emotional events—good or bad—we may want to make sure to connect with loved ones and tell them we love them. That is something we all like to remember to do and know that we did. We might also consider doing things that scare us, experiences that get the blood flowing—this wakes up the amygdala and the emotional aspects of these experiences will make them more memorable.

HAPPY MEMORY TIP:
DO SOMETHING THAT SCARES YOU

Stepping out of your comfort zone can be the first step towards making more memories.

As they move in a silent embrace across the floor, her eyes are closed. A subtle smile plays on her face as she rests her hand on his shoulder. Every woman on the floor seems to be wearing that same smile as the twenty couples circle around the empty spot in the middle where the nonexistent band is playing. The music of Carlos Gardel's *Por una cabeza* is filtered through the sound of shoes sliding gently on the floor.

I grew up in rural Denmark. Men went hunting and fishing—dancing, not so much. In addition, I am a terrible dancer. I genuinely believe that pointy fingers and overbite is a legitimate dance move. Despite all this, a girl I went to university with convinced me to take a tango class. I was completely out of my element.

There are no fixed steps in tango. You make it up as you go along—walking in a silent embrace with no plan and no words. How do you communicate without words but with balance and pressure? I needed to stop thinking and start sensing.

In my first lesson the instructor placed a tambourine between my chest and hers and put her mouth so close to my ear I could feel her breath. This was an exercise to teach us men to communicate the direction we were going in through our chest and not with our arms.

"Press harder, otherwise the tambourine will fall," the instructor said into my ear. "Harder. Yes, that's it. Don't stop. Don't stop." It was my first tango lesson—and sparked four years of tango lessons. So, consider what you could do outside your comfort zone and make memories for the future.

SOMEBODY I USED TO KNOW

Wendy Mitchell is from Yorkshire. She worked for decades as a team leader in the NHS. She was active. She ran. Hiked up mountains. Raised two daughters, Sarah and Gemma, by herself.

Then, one morning in September 2012, Wendy goes for a run along the Ouse River in York. She trips. Falls hard. Blood flows. She goes to the emergency room and is looked after. Later, she returns to the place along the river where she tripped to try and find the stone or hole that caused her to fall. She recognizes the spot by the blood, but there is no obvious cause for the fall.

Another run. Another fall. Then another. She feels uneasy. Foggy. Less sharp than usual. She knows something isn't right. On July 31, 2014, almost two years after her first fall, Wendy is diagnosed with early-onset Alzheimer's.

Today, she finds writing easier than talking and, with the help of a ghostwriter, she wrote *Somebody I Used to Know*. It's a gripping and heartbreaking story—and an insight into what we lose when we lose our memories. It shows the challenges of living with dementia. How finding your way home from your favorite café becomes an issue. Or finding where in the kitchen you keep the tea.

But it is also an inspirational and heartwarming story. It shows how she's taken control of her life. Wendy is resilient and resourceful and she is finding ways to outwit the disease for as long as she can.

She arms herself with stacks of Post-its. An alarm reminds her to take her pills. Pictures on the cupboards show her where the tea is kept. She has bought a pink bike—not because she loves pink but because it is easier to spot and remember. Novels have become impossible to read, so she enjoys poems and short stories instead.

But the hardest thing seems to be how dementia steals our cherished memories from us. Every night, a thief steals something more precious than any possession. Wendy tries to fight that, too. She stares at a photograph from 1987. There is a sandy beach. A blue sky. Her two daughters, aged six and three, smiling at the camera. As she tries to memorize every detail, the thought of the day she will no longer recognize those two smiling faces as her daughters' is heartbreaking.

She has created a "memory room" with photographs in rows across the walls. She labels them. The "where?"s, the "who?"s, the "why?"s. One row has her daughters, another the places Wendy lived, a third her favorite views—the Lake District and Blackpool Beach.

"I sit on the edge of the bed in front of them, feeling that same sense of calm and happiness. When the memories have emptied on the inside, they'll still be here on the outside—a constant, a reminder, a feeling of happier times," she writes.

Wendy describes our different memory systems as bookcases. There is a bookcase for facts and a bookcase for emotions. The bookcase for facts is tall and wobbly, with the most recent memories at the top; the emotional bookcase is short but sturdy.

"We never lose our emotions, because that is a different part of the brain," Wendy said in an interview on the *Guardian* book podcast. "Details and facts, we lose every day. For example, I won't remember what we have talked about here today tomorrow—but I will remember how I felt coming here. The emotional bookcase is important to remember, as people forget who loved ones are. They still have this recognition that there is an emotional attachment."

Or, in the words of Maya Angelou, the American poet, singer and civil-rights activist: "I've learned that people will forget what you said, people will forget what you did, but people will never forget how you made them feel."

Wendy is now an ambassador for the Alzheimer's Society. She is committed to helping health-care professionals, caregivers and people living with dementia and she is fighting to reducing the stigma around the disease. You can follow her blog: "Which me am I today" (whichmeamitoday.wordpress.com).

HAPPY MEMORY TIP:
TEN YEARS' TIME TEST

When choosing what to do, take into account what you are most likely to remember in ten years' time.

For the past twenty years, I've gone sailing with one of my friends, Mikkel, and his dad, Arne. We've sailed around the Danish islands, into Swedish fjords and sunk a few Irish coffees on the way. We've done this for so many years it is becoming increasingly difficult to distinguish the trips from each other.

So this year we decided to do something different. We rented a sailboat in the Adriatic Sea and docked at towns such as Trogir, Milna and Hvar. Towns with narrow streets, towers and keeps, built with stones that glow when the sun sets; towns that could work as the set for King's Landing in *Game of Thrones*. This year, Deny, Arnes's son-in-law, also joined us. His special pirate skill is knowing exactly when the crew is in need of an Aperol spritz.

One afternoon, as we were approaching Hvar, we dropped anchor in a bay to have lunch and swim. A shoal of small blue fish congregated around the end of our boat. The water was crystal clear and, when we lowered the anchor, we could see it all the way to the bottom of the bay.

If you look for it on the map (roughly 2 kilometers west of Hvar), the bay looks like the Christ the Redeemer statue in Rio de Janeiro. So, naturally, we had to name it Jesus's Bay.

The next day, after visiting the castle of Hvar, Mikkel and Deny suggested that we rented a jet ski so that we could go back to Jesus's Bay for the afternoon. Jet skiing had never appealed to me. I am no fan of speed or machines. I am more a difficult-crosswords-and-long-books kind of daredevil. Indeed, I had planned to spend the afternoon on the boat with a book.

However, when I asked myself, "What are you more likely to remember in ten years?" the jet skis seemed to be the stronger contender. An hour later, we were racing back to Jesus's Bay, gliding on top of the water, bouncing off every wave, circling the small, uninhabited islands we passed on our way. It was a memorable afternoon. "Each time I got close enough," Mikkel said to me, "I saw a huge grin on your face." It was indeed the most fun I had had in a long time.

We spent the evening drinking rum, listening to Bruce Springsteen and The Rolling Stones, and arguing good-naturedly over whose fault it was that I overturned and fell in the water.

It was Mikkel's.

So, once in a while, when planning your day off, make sure you put the options through the Ten Years' Time test. What will I remember in a decade?

USING THE EMOTIONAL HIGHLIGHTER PEN IN SCHOOLS

The power of the emotional highlighter pen when it comes to memory is now being harnessed by schools aiming to use episodic memory to enhance students' semantic memory.

"A girl was taking her exams in history. She was a special-needs student and had not been doing well in her old school," says Mads, the headmaster of Østerskov Efterskole, a boarding school in Denmark with ninety students. "I think her teacher got a bit nervous when the girl was asked to explain the mechanics of the senate of the Roman Republic. But she clearly outlined the inner workings of the government of ancient Rome and how it connected with the rest of the Roman Republic. She received a grade that would be equivalent to A– in the American grading system."

As the student left the exam, the adjudicator asked her, "How did you know all this so well?"

"It wasn't difficult," the girl replied. "I was there."

Efterskole is Danish for "after school" and they are independent boarding schools for young people between the ages of fourteen and eighteen. Students can choose to spend one, two or three years finishing their primary education here. Some take it as an extra year after finishing primary school to have a break before they start high school.

What is special about Østerskov Efterskole is that they use LARP to teach the students. LARP is short for Live Action Roleplaying and could be considered a mix between Dungeons and Dragons and a civil war re-enactment.

Each week there is a theme and the students are assigned a role and a mission. They may be NGOs preparing for a climate conference, trying to influence the lawmakers of the world. They may find themselves on Wall Street as bankers, as senators in ancient Rome, or Foreign Ministers in Brussels negotiating the future of Europe.

In the Roman Republic week, the students play members of different noble families in ancient Rome. Their aim is to rise in power and make their mark on history. In maths, students use trigonometry to solve the problem of water supply and to connect Rome with elevated reservoirs via aqueducts.

In physics, the students learn about metals—their qualities, where they are found and why some are better suited to equip a Roman legion with swords and shields. In German, the students need to buy slaves from a German-speaking slave trader to harvest their fields; this creates an incentive to learn the vocabulary to buy efficient workers. Later that week, their German teacher plays a Gothic warlord presenting territorial claims on behalf of his tribe and the students have to negotiate the terms and conditions of the peace in German.

Studies led by Lisa Gjedde, professor at the Faculty of Learning and Philosophy at the University of Aalborg, Denmark, show that using LARP improves motivation and long-term memory. Grades either remain the same or are improved by the method.

HAPPY MEMORY TIP:
EMBARRASSMENT SHTICK

Sharing embarrassing stories can make them lose their power.

I still remember my first days at the Ministry of Foreign Affairs in Denmark vividly. The building is located by the waterfront in central Copenhagen and filled with iconic Danish design classics. I remember walking down the long carpet-clad hallway on the third floor to my office. I remember meeting Sune, one of my new colleagues, for the first time. This was the office for Africa.

We chatted for a minute, and I remember his exact words as he said, "I'm sorry, but I think you might have stepped in something."

Indeed I had. A dog turd. A big one. One that seemed to have my shoe in a chokehold. I had smeared it on the carpets in the new office, and on the carpets in the long hall. One hundred meters of humiliation.

If you are one of those people who is just walking along and suddenly remembers that embarrassing thing you did years ago, don't worry, you are not alone.

Embarrassment sticks. But you may want to turn it into a shtick. Your thing. Your go-to joke. I've found that my embarrassing moments lose some of their power if I take control of them and laugh at them.

The story of my first day at the Ministry of Foreign Affairs is on page one of the employee manual at the Happiness Research Institute. I want my new colleagues to know that, whatever mistake they might make in their first week, I've made worse.

In addition, sometimes, when I do a presentation, I will start with the "Danish porn" story, just to let people know that English is not my first language and that if there is anything that is unclear, they should feel free to raise their hand and ask questions. Perhaps you could also consider how you can take some of your embarrassing moments and turn them into entertaining anecdotes—it could be a way of stripping them of their power.

CAPTURE PEAKS AND STRUGGLES

THE PEAK—END EFFECT

So let me ask you a question. Imagine that, at the end of your next holiday, you will forget everything.

You will have no memory of the beauty of Kyoto's temples, no memory of hiking to the top of Mount Fuji, and absolutely no memory of murdering "Yesterday" in one of Tokyo's many karaoke bars. Your memory—gone. Your pictures—gone.

The question is, if, at the end of your next holiday, you knew you would be given a drug that would cause amnesia and you would not be able to remember anything, how would you plan your holiday? If you would experience it, but have no memory of that experience, what would you do?

This thought experiment was first posed by Daniel Kahneman, Professor of Psychology and Public Affairs Emeritus at the Woodrow Wilson School and the Eugene Higgins Professor of Psychology Emeritus at Princeton University. Even though he is not an economist, he received

the Nobel Memorial Prize in Economics in 2002. He has been presented with an Award for Outstanding Lifetime Contributions to Psychology by the American Psychological Association and he has been awarded the Presidential Medal of Freedom by President Obama. It is difficult to remember all this—so just think of him as the Beyoncé of behavioral economics.

Among other things, Kahneman has studied how our "experiencing selves" and our "remembering selves" perceive happiness differently. The experiencing self, who lives in the present, or for about three seconds at a time, 500 million times throughout our lives, and the remembering self, who is relatively permanent and does their best to keep a track record of all their experiences. In other words, our remembering self is the one that tells the story of our life.

Going back to the holiday, for the experiencing self, the second week of a holiday is just as good as the first. Two weeks' holiday is therefore twice as good as a one-week holiday. But for the remembering self, if the second week was similar to the first week, it did not produce additional memories, so there was no additional benefit. The story is the same: Went to Cancun, water was warm, drank Margaritas; it was nice.

So that was a thought experiment—but actual experiments have also shown that the experiencing self and the remembering self disagree.

In one study, Kahneman and his team asked the participants to put one hand in water which was 14°C for sixty seconds. The National Center for Cold Water Safety calls 14°C "very dangerous." (In Denmark, we call it summer. Mind you, the participants were students at the University of California. Anyway . . . let's get back to the study.) That was the first trial. In the second trial the participants were asked to put their other hand in water at 14°C for sixty seconds then keep that hand in the water for thirty seconds longer as the temperature of the water was gradually raised to 15°C, still painful, but distinctly less so for most participants, who indicated their level of discomfort during the experiment.

After the two trials—the shorter, sixty-second trial in 14°C water, and the longer sixty seconds in 14°C then thirty seconds at 15°C—the participants

were given a choice of which trial to repeat. A significant majority chose to repeat the second trial, the longer one, with as much pain as the first trial, plus a little more. Apparently, they preferred more pain over less.

The study by Kahneman suggested that duration plays a small role in retrospective evaluations of experiences; such evaluations are often dominated by the discomfort at the worst and at the final moments of episodes. This is called the peak–end effect, or peak–end rule.

Kahneman and his colleagues have tested and retested this peak–end effect with film clips, getting people to watch other people's discomfort—even colonoscopies.

Colonoscopy patients were randomly divided into two groups. The first group underwent a normal colonoscopy procedure. The second group underwent the same procedure, but the scope was left in for three additional minutes, but not moved during that time, creating an experience that was uncomfortable, but not painful.

Kahneman and his team found that when the patients were later asked to evaluate their experiences, the patients who underwent the longer procedure rated their experience as less unpleasant than the patients who underwent the typical procedure. Moreover, the patients in the second group with the prolonged procedure were more likely to return for subsequent procedures because a less painful end led them to remember the procedure more positively.

According to Kahneman, the peak–end rule is that our memory of past experience (whether pleasant or unpleasant) does not correspond to an average level of positive or negative feelings but to the most extreme point and the end of the episode.

It can also be seen as the tyranny of our memory. The tyranny of our remembering self is dragging the experiencing self through an experience that is more unpleasant for the experiencing self. In that sense, our remembering self is kind of a prick.

Several studies have demonstrated the peak–end rule. And it goes beyond pain, and applies to material goods—in fact, Hallowe'en candy.

Researchers Amy Do, Alexander Rupert and George Wolford from Dartmouth College in the US set up their experiment in a house that was frequently visited by children on Hallowe'en night.

On Hallowe'en, twenty-eight trick-or-treaters with the average age of around ten came to the house. All the kids were given different combinations of candy and asked to rate their happiness levels in relation to it. Seven different happiness levels were shown by using smiley-face symbols ranging from neutral to "open-mouthed-grin smiley face." Some kids were given a full-size Hershey's chocolate bar, some kids were given a piece of gum, some kids were given first a Hershey's bar then a piece of gum, and some kids were given first a Hershey's bar then another Hershey's bar. You would expect more candy to equal more happiness. But the children getting a chocolate bar then a piece of gum were less happy than the kids who received just the chocolate bar. And two chocolate bars did not bring more happiness than one chocolate bar.

Source: Do, Rupert and Wolford, "Evaluations of Pleasurable Experiences: the Peak-End Rule," *Psychonomic Bulletin & Review*, 2008.

In a similar study, a group of five Dutch pedagogical and educational researchers explored how the peak–end rule affects how children experience feedback from their friends.

Seventy-four primary school children around the age of ten took part in the experiment and were told that they would receive feedback from their classmates about their behavior, for example, "How well do you think Meik communicates with other children in the class?" or "How well do you think Meik follows the rules?" The ratings were "insufficient," "insufficient to sufficient," "sufficient," "sufficient to good" and "good."

First, the participants were asked to assess two of their classmates, then, later, the participants would receive the feedback on them. Students were led to believe that the feedback was from the assessments filled in by their classmates; however, the feedback they received was manipulated by the experimenters. At this point, you should know that the parents of the children had been informed about the experiment and had given their consent, the children had been tested for depression and anxiety and the study had been approved by the Ethics Committee of the Institute of Psychology of the Erasmus University Rotterdam. Nevertheless, I still think it's a bit mean.

Thirty of the kids received an assessment consisting of (a) four negative ratings (insufficient) and (b) another assessment consisting of one of four negative ratings followed by one moderately negative rating ("insufficient to sufficient").

The forty-four other kids also received two assessments, but instead of negative ratings they received positive ones: first, four positive ratings (c) then another assessment with four positive ratings followed by one moderately positive rating (d).

The students were then asked how pleasant it was to receive the assessment and to what extent they would like to receive this assessment again, on a scale from 0 to 100. As expected, the students found the negative assessments very unpleasant and the positive assessments very pleasant.

The students who had received negative assessments preferred (b) over (a)—feedback that finished with a moderately negative assessment; and the students who received the positive feedback preferred (c) over (d)—the assessment without the moderately positive ending.

The study suggests that evaluation can be made more pleasant for students by ending with the best part of the evaluation and that the order of the feedback may have an impact on motivation, learning and the relationships between the students.

So the take-home message is that, in the art of making memories, we need to keep in mind that the ending is important and the peak is important. And sometimes, to reach the peak, we need to struggle—and when it comes to memorable experiences, that might not be a bad thing.

HAPPY MEMORY TIP:
END ON A HIGH NOTE

Save the best for last.

Across different studies, it has been demonstrated that our memory of an event is heavily influenced by the peak and the end. So, if you're planning on giving several gifts for Christmas or a birthday, make sure you save the best one for last. Also, since remembered utility is an important influence on our future choices, if you want your kids to participate in something again, be sure to end on a high note.

THE STRUGGLE IS REAL MEMORABLE

Last year, I was in Rome for the launch of the World Happiness Report.

As well as taking part in the conference and catching up with other happiness researchers, I had another objective in Rome: getting my hands on an ancient Roman coin. But not just any old Roman coin, one with the Roman goddess Felicitas on the back.

Felicitas signifies a state of peace, prosperity and general good fortune. On the coin, she holds in one hand a cornucopia—also known as the horn of plenty—a symbol of abundance and nourishment. In her other hand she holds a caduceus, a short staff entwined by two serpents, which represents Mercury, the Roman equivalent of the Greek god Hermes, symbolizing trade and prosperity.

At the Happiness Research Institute we have been gathering pieces for our Happiness Museum in Copenhagen, which is scheduled to open after this book is published. It will be an exhibition on the Science of Happiness. How do we measure happiness? The Anatomy of Happiness. Where in the brain does happiness sit? The Atlas of Happiness. Why are some countries happier than others? And the History of Happiness. How has the concept of happiness evolved over time? The ancient Roman coin is a part of that collection.

I had found it online, but I wanted to find it in Rome because it would make a better memory. Yes, it would require more effort than just adding it to the online basket. I had researched and found three different numismatic shops in Rome. The first one was just around the corner from my hotel near the Vatican. It was a tiny shop, around 7 square meters, and the selection was limited, with no coins depicting my desired goddess. I continued on foot to the second shop, located on Via del Corso, the main shopping street

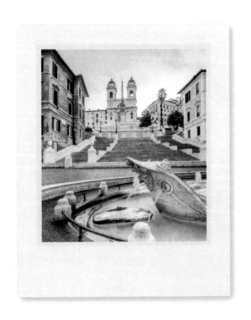

in Rome. After searching for the shop for a while, I came to the conclusion that it had shut down a while back and had been replaced by a clothes shop. So my last hope was the third shop—Filatelia Central on Via due Macelli, a five-minute walk from the Spanish Steps, entered through a tiny alley. I say "walk"—but it was the end of the day and, afraid the shop would be closed, I began to run. I found the store and told the gentleman there what I was looking for.

"Maybe we have something," he said, "but we'll have to search for it."

The thing is, the coins were organized according to which emperor was on the front, not what was on the back, so we examined hundreds of coins, turning them over, studying the back with a magnifying glass. A magnifying glass! How awesome is that! I realized that I use a magnifying glass way too little.

After three quarters of an hour, Felicitas suddenly appeared in the magnifying glass. On the front of the coin was Publius Septimius Geta, who was emperor for three years. Geta was the younger son of Septimius Severus (who came after Commodus—the guy whose ass gets kicked by Russell Crowe in the movie *Gladiator*). Geta and his older brother Caracalla were presented as equally suitable heirs to the throne—perhaps to show more "depth" to the dynasty—and had pledged on the deathbed of their father to remain united. However, just a few months after Severus's death, his sons formed rival factions and fought for supremacy. Pretending that he was hoping for reconciliation, Caracalla scheduled a meeting at their mother's house, but, instead, Geta was ambushed and murdered. Afterwards, Caracalla ordered sculptures, coins and images of his brother to be destroyed so that Geta would be forgotten.

This reminded me of something the psychologist Dorothy Rowe pointed out about siblings. When kids are young, they fight over their parents' attention, but when they get older, siblings battle over who has the most truthful, accurate memory of their shared past.

But Caracalla did not get his way—and I got my coin. After a bit of an adventure and magnifying-glass lollapalooza.

That is what makes it memorable. In the Happy Memory Study we conducted at the Happiness Research Institute, 22 percent of people's memories involved a peak or a struggle. Sometimes, the struggle was the main part of the story. Imagine if Indiana Jones had simply stumbled upon the Arc of the Covenant (Oh, *that's* where I left it!), or if he'd ordered the cup of Christ on eBay. Both stories would make really lousy movies. Overcoming the struggle is why we celebrate. The peak is the peak because of the climb.

And yes, I did partly acquire the ancient Roman coin so I could deliver the Indiana Jones line, "That thing belongs in a museum."

The shopkeeper didn't get it.

HAPPY MEMORY TIP:
CONSIDER TAKING THE LONG ROUTE

Make the journey part of the experience.

In an era of impatience and instant gratification, one way to make things more memorable is to delay your arrival. If you have spent five hours hiking to the peak, it makes the experience greater than if you took the fifteen-minute cable car up there. For some trips, it may also make sense to take a train instead of a plane. You will get there slower, but you may have a much more enjoyable journey. Trains—the tantra of travel.

THE MORE UPHILL THE STRUGGLE, THE SWEETER THE VICTORY

To me, soccer is like watching grass grow with people in the way. I've never understood why twenty-two people running around after a ball is so fascinating. It would be equally rational if people were passionate about, say, origami.

Imagine that every morning the news broadcast ends with the latest results in origami. The Chinese team of folders won the match against the French team with a swan. Eighty-eight folds. It would be followed by the advertisements for the big game, Barcelona versus Madrid, the archrivals of origami. Last season, the lead folder in Barcelona, Takahashi, was transferred to Madrid for $1.2 billion. As a consequence, Barcelona fans—the Shredders—were furious and assaulted fans from Madrid.

On your way to work, you see origami folders on billboards. They are paid millions to advertise luxury bags, cars and perfumes: A4 by Calvin Klein. At work, you grab a coffee and say good morning to your colleagues. "Did you watch the fold last night? France will totally lose out on the OWC." That's the Origami World Cup. Four weeks of non-stop live broadcasting of men folding swans, dolphins and giraffes. Exciting stuff. Women fold, too, but they are paid around 10 percent of what men are.

Professional folders who have retired now work as commentators. "Oh my God, he's going for the hippo. He's going for the hippo. The audacity. Classic Takahashi strategy. Oh, no, my God. A papercut! Oh, no—he'll be out for the season. That is a devastating blow to the Japanese team."

All the countries in the world aim to compete in the OWC—except the US, as they use a different shape of paper—a shorter, wider one than the A4, so their teams compete in a different league. If you stand next to a group of men in the pub, you will overhear a fiery discussion over A4 versus the 8.5 by 11 inch. "You'll never get a proper giraffe out of the A4, mate!"

Later that day, the discussion over lunch is the news that the American origami champion has been found guilty of doping. His thumb and index finger have been injected with a small bit of metal, enabling him to make sharper folds.

"Happy birthday," say the friends you meet after work. "Thanks, guys," you say, unwrapping their present to you. It's a book, a memoir: *Unfolded* by Takahashi.

In short, I don't care about soccer. Sorry, I just needed to get that out of the way. Because my favorite study in 2018 was in fact about soccer. "Is Soccer a Matter of Life and Death—or is It More Important than That?" by Peter Dolton and George MacKerron, published by the National Institute of Economic and Social Research.

The study examines how the results of soccer matches affect the happiness of the fans and used data taken from 3 million responses by 32,000 people from the Mappiness App, a research project at the London School of Economics. Its aim was to understand how people's feelings are affected by their environment. The participants in the study are "pinged" via their smartphones and asked to complete a short survey containing questions about their well-being in that given moment: how happy, how relaxed and how awake they feel. They are asked who they are with, where they are and what they are doing. In the question about what they are doing, they can choose between forty options, including attending a sporting event. GPS data is also collected via their smartphones, so the researchers can use the assumption that, if you are at Old Trafford every time Manchester United plays a home game (and registered that you are outside, at a sporting event, and not working), you are likely to be a Manchester United fan and therefore see how your team winning or losing affects your happiness levels. Armed with this data, the researchers can combine it with when different teams are playing, the results of the match and expected results by using the bookmakers' odds for any given match.

The study finds that the marginal effect on happiness in the hour after the game for a win, draw or loss for your team are, respectively, 2.4, –3.2 and –7.2, if you were not at the stadium. If you were at the stadium, winning will give you a plus on happiness of 9.8, a draw will set you back –3, and a loss will be felt more heavily, with a rating of –14.

This supports something called the loss-aversion affect—the notion that we hate losing much more than we enjoy winning. The study also finds what we would anticipate—that if we expected to lose (based on the odds at the bookmakers') then won, the victory will be even sweeter. Similarly, fans were even more unhappy if their team lost when a win was expected.

Of course, there is also the enjoyment (for some people) of the match itself and the enjoyment of looking forward to the event. There is a large spike in happiness before the match. However, overall, the findings demonstrate that "people are much more negatively affected by the adverse results of match defeats than they are positively affected when their teams win. This effect lasts much longer and may add up to around four times the negative impact on happiness for a defeat as compared to the positive effect of a win."

In short, soccer fans are irrational. From a happiness point of view, being a fan of soccer is a bad idea. The accumulated effect of following soccer is negative. Nevertheless, it can provide a source of happy memories. Here is an American soccer mum who took part in our Happy Memory Study: "I watched my daughter score her first goal in soccer for her high school team. It was the first goal of the season in the first game and the first time her high school had scored against the other school in five years."

PEAK — END WEEKEND

So, which day of the week offers the best chance of happy memories? Which days are our happiest and least happy? Seems like a really simple question—however, the answer is not so simple.

The Mappiness Study also collected data from 22,000 people over a two-month period to explore the effect the day of the week had on happiness, and exonerated Mondays. Tuesdays are the worst day. One theory by the researchers is that, on Mondays, the weekend effect still lingers, but on Tuesday it is gone and next weekend is still way off in the distance.

However, another study, published in the *Journal of Applied Social Psychology* by two researchers from the University of Sydney, found that mood was lowest on Mondays. A third study found no variation across the weekdays. So the jury is still out on the Blue Monday effect.

However, the weekend effect is detected across the various studies. For many, it is the highlight of the week. People report high levels of happiness on Fridays, Saturdays and Sundays. Some studies show a dip on the Sunday, as people realize the weekend is about to end.

The reasons why people experience higher levels of happiness at the weekend include greater autonomy, more relaxation and more connection with others. During the week, there are more things that are beyond our control and we face constraints on our time, with meetings, managers and deadlines. We are forced to spend time with people we do not necessarily connect with. At the weekend, we can, to a greater extent, choose activities that bring us joy and spend time with the ones we love the most. Many of us, of course, have to work at weekends, and people who do not fit into the classic nine-to-five schedule would of course report different results.

In conclusion, on average, people are happier during weekends. Thank you, big data, for that nugget of wisdom. However, taking Kahneman's peak-end theory into account, this might work in our favor. If we end the week on a high note, we may look back on that week more fondly.

CHORE WARS — WHY MEMORY MAKES US FIGHT

━━━━━━━

In 2010, a survey conducted by Cozi, a company offering family organizers online, asked 700 men and women with children about their share of various household chores, for example, grocery shopping, gift shopping, household financing, scheduling and planning.

Basically, it was a comparison of how hard Mum and Dad work in the home—or at least how hard they *think* they work.

For instance, men claimed they did 55 percent of the planning and scheduling. However, women claimed *they* did 91 percent. That adds up to 146 percent. And the same goes for every chore on the list. The combined share of what men and women claimed they did of each chore exceeded 100 percent.

So what is going on here? Well, in social science, we often run into what is called the social-desirability bias. People over-report good behavior because we have a desire to be seen favorably by others. "How often do I donate money to charity?" you ask. "Well, all the time. In fact, here's some money. Take it. Please like me." Even if the survey is online and anonymous, we cannot rule out the social-desirability effect. We like to tell ourselves stories about how good we are.

But another factor may also be at play: our memory. Take grocery shopping, where both men and women claim that they do the majority of the work. Men claim they do 46 percent and women claim they do 77 percent. A total of 123 percent.

What happens may be that the memory of when we did the chore simply sticks better. When I do the grocery shopping, I experience searching for artichokes (I had to go to three places to get them), I experience picking the wrong queue at the checkout (Come on, you have to weigh the apples and put the price sticker on?!), I experience carrying the heavy bags home (Why did I pack all the heavy stuff in just one of the bags?).

When you do the grocery shopping, my experience is: "Yum. Artichokes! Oh, good, we got milk." It is a less vivid memory. When I first read about this study, I felt like phoning a couple of ex-girlfriends.

	Men claim they do	Women claim they do	Total share claimed
Scheduling and planning	55	91	146
Back-to-school shopping	57	88	145
Holiday gift-shopping	60	80	140
Grocery shopping	46	77	123
Home repair and maintenance	79	37	116
Household finances	70	62	132
Yard work	69	42	111
Seasonal projects	65	63	128

USE STORIES TO STAY AHEAD OF THE FORGETTING CURVE

"I went to a freezing, windy, wild beach this summer with my husband and children," writes one of the participants in the Happy Memory Study we conducted at the Happiness Research Institute, a woman from the UK in her thirties.

"We were determined to have porridge and oatcakes cooked on a fire pit for breakfast, only for us to end up eating cold, raw porridge and rubbery oatcakes flavored with mountains of sand. Lots of laughter and unrivaled family time." When asked why she thinks she still remembers the event today, she replied, "Because, despite everything that was going wrong, it was one of the funniest experiences of my life, and one that I shared with my family. No phones, no TV, just the four of us, all wrapped up in big blankets, watching wild waves crashing, huddled around the fire pit, eating horrendous food and being covered in a layer of sand."

I love this story. If we don't do anything stupid, if things don't go wrong, we don't have any stories to tell. I'm sure that story is going to be one of the classics in that family. It is our common stories that bind us together. Thirty-six percent of the memories we collected in the Happy Memory Study were remembered by the participants because the memories have been turned into anecdotes and stories.

In addition, our well-being is influenced by our ability to form a favorable narrative of our lives. Do we ruminate over failures and mistakes, or are we able to find the silver lining in our struggles? What aspects we focus on when we tell the story of our life, the story of how we became who we are, has an impact on our sense of self.

One study by Dan McAdams, professor of psychology at Northwestern University in Illinois, shows that an ability to construct stories of personal redemption is associated with higher levels of mental health and well-being. A redemption story is a situation that starts bad and ends better, for example, cold porridge: bad; laughing with the family: better.

Because of ripped Santa—the retrieval of a memory strengthens the memory—it means that the way we shape the stories of what happened shape the way we remember those events. Our stories are our attempt to make sense of the world. Telling a story of an experience means rehearsal, it means strengthening the connection between some pieces of information in our brain, making the memory more memorable. Or, in the words of Muriel Rukeyser, the American poet and political activist, in *The Speed of Darkness*: "The universe is made up of stories. Not atoms."

HAPPY MEMORY TIP:
COLLECT OBJECTS THAT ARE
A MANIFESTATION OF YOUR STORIES

Make sure your things tell your stories.

When I look around my home office, I see paintings, photographs and objects. One painting is of the farm where my grandfather grew up. There was only an outside toilet and, one afternoon, as my grandfather was in there doing his business, he heard Dr. Brenner's car. Dr. Brenner was the first in the town to acquire a car so, at the roar of the engine, my grandfather knew it was him. Wanting to see the car, my grandfather climbed up to look through the window, but slipped and fell into the latrine. It may not be a great painting, but it does remind me that curiosity will land you in the shit from time to time.

I also have a photograph taken between 1912 and 1919 of the Spanish poet Antonio Machado with the rest of the staff at the school where he taught in Baeza. As you may remember from my reminiscence bump, I spent three months in Baeza writing, and the picture was a gift from a teacher there and the editor of a magazine that published a short story of mine.

On one of the shelves there is a camera which my grandfather gave to my dad in 1958. My dad was around ten; it was when Khrushchev became leader of the Soviet Union, President Eisenhower established NASA, and Elvis bought Graceland for $100,000. It has a wonderful metallic click when you press down the shutter and reminds me of the passage of time and how we may shape the legacy we leave behind.

When I look around, I realize I have not furnished the room with paintings and objects, I have furnished it with stories.

Manifestations of stories do not have to be expensive things. If your family has a redemption story about eating raw porridge on a freezing, windy beach, a simple rock from that beach might make your kids think about that fun, crazy experience that brought you closer as a family. But, of course, everything in moderation. No need to go full Andy Warhol on this.

THE POWER OF STORIES

Have you ever been to a party and someone tells a funny story—for instance, their brother used to eat mustard out of the jar and grab their dog by the testicles—and you realize they are telling your story? That is your funny story. Your memory. John is your mustard-eating-dog-testicle-grabbing brother.

If you have, then you have experienced another memory phenomenon: disputed memories, in which people disagree over who experienced the memory.

In one study published in 2001, Mercedes Sheen and Simon Kemp, today professors in psychology at different universities but at the time both teaching at the University of Canterbury in New Zealand, and David Rubin, who taught at Duke University in the US, conducted three experiments with siblings, including twins.

In one of the experiments, twenty sets of adult twins were cued with forty-five words and asked to think of a memory for each word. Fourteen of the twenty pairs produced at least one disputed memory: thirty-six disputes in total. Fifteen of these were old disputes—but twenty-one of the disputes were discovered during the experiment.

The twins were of the same sex and, on average, twenty-seven years old at the time of the experiment, and the disputed memories were of a time when the twins were aged between five and fourteen.

In one case, both twins thought that they had come twelfth in an international cross-country race; another pair argued over who was in a boat with their father when they saw a tiger shark; and a third set both believed that they fell off a tractor and sprained their wrist.

And, in the case of eating half a jar of mustard and grabbing the dog by the testicles, both claimed that the other twin did it. I say we put the dog on the witness stand.

In the second experiment, siblings—but not twins—of around the same age were also found to disagree on the ownership of memories, but less often than twins. It makes sense that twins should have more incidents of shared ownership of a memory. They are exactly the same age and more likely to have had some of the same experiences, compared to regular siblings.

In a third experiment, the researchers found that disputed memories are remembered as more vivid—higher in imagery and emotional reliving— compared to non-disputed memories. In part, this may be down to the fact that these *are* disputed memories and the participants are keen to convince the researchers that the memories are in fact theirs.

But what is the reason for these disputed memories in the first place? Why do two or more people seem to have the same memory?

Well, if you are a diamond-level conspiracy theorist, you might say it was a glitch in the matrix. But it may also be due to what is known as the memory-source problem.

Let me give you an example. I've written before about *hygge*—the Danish art of creating a nice atmosphere—and when I talk about *hygge*, I will often try to explain what it is with the following story:

One December just before Christmas, I was spending the weekend with some friends at an old cabin. The landscape was covered in snow, which brightened the shortest day of the year. When the sun set, at around four in the afternoon, we would not see it for seventeen hours, and we headed inside to get the fire going. We were all tired from hiking and, in a semicircle around the fireplace in the cabin, people were half asleep, wearing big sweaters and woollen socks. The only sounds you could hear were the stew boiling, the sparks from the fireplace and someone having a sip of their mulled wine. Then one of my friends broke the silence.

"Could this be any more hygge?" he asked rhetorically.

"Yes," one of the girls said after a while. "If there was a storm raging outside."

We all nodded.

Last year, I shared this story in St Petersburg and, afterwards, a member of the audience said that she could hear the fire crackling. Sometimes, we manage to bring stories to life. To make them so vivid that our listeners experience it with their own senses. We use some of our own personal experiences to do this. When you hear the *hygge* story, you know from your own personal experience what a crackling fire sounds like, how the smoke from dry wood smells, and how the flames dance between red, yellow and blue, you know how the fire feels, warming your front but leaving your back cold.

So you take details from other experiences, from other sources, and add them to the story. The story is now more vivid, it has details about your personal experiences, so you can start to believe that it is your story—your memory. You feel you have witnessed it with your own eyes, but in fact you heard it from someone else and the hippo in the director's chair just got creative.

What great storytellers do is bring the stories to life. Stories well told become experiences, stories so vivid you feel you witness it with your own eyes. What we can learn from this is that we might be able to help our loved ones rebuild a memory that they have lost—and rebuild it in such a manner that they don't know it is a replica.

THE MANDELA EFFECT

––––––––

One of the most popular TV series in Denmark is Matador, *a drama about life in a small town in Denmark set in the Great Depression and throughout the Nazi occupation.*

In one episode, the character Misse, an anxious elderly spinster, gets married to teacher Andersen. However, on their wedding night, Andersen turns into a "wild beast," according to Misse, as he wants to consummate the marriage. She locks him out on the balcony and he stands there all night in the cold, yelling.

Many Danes will describe that scene. Andersen in his pyjamas yelling at Misse. Banging on the door. The only issue is that the scene was never shown or filmed. However, many Danes believe they have seen it, but in fact it was their imagination creating that scene—and the subsequent memory of it—in their mind.

This is known as the Mandela effect—where many people have a false memory about something. The name comes from the phenomenon that a lot of people remember that Nelson Mandela died in prison in the eighties and TV coverage of his death and funeral from that time—even though he was released from prison, became president and lived until 2013.

You might suffer from the Mandela effect, too. Remember the iconic scene in *Star Wars Episode V: The Empire Strikes Back* where Luke is fighting Darth Vader?

"If only you knew the power of the Dark Side. Obi-Wan never told you what happened to your father," says Vader, and Luke replies: "He told me enough! He told me you killed him!"

The question is, what does Vader say next? A lot of people will say, "Luke, I am your father." But that is a false memory—the line is actually: "No, *I* am your father."

Oh, and since I mentioned *Casablanca* earlier, I should probably also mention that the character Bogart plays doesn't say, "Play it again, Sam." Rick says, "Play it!" in a frustrated and angry tone.

We often remember things wrongly. Even important, world-changing events.

An example of this is George W. Bush's memory of seeing the first plane fly into the World Trade Center on September 11 when he was asked a few months later how he had felt when he heard about the attack.

> *I was in Florida. And my chief of staff, Andy Card—actually, I was in a classroom talking about a reading program that works. And I was sitting outside the classroom, waiting to go in, and I saw an airplane hit the tower—the TV was obviously on, and I used to fly myself, and I said, "There's one terrible pilot." And I said, "It must have been a horrible accident." But I was whisked off there—I didn't have much time to think about it, and I was sitting in the classroom, and Andy Card, my chief, who was sitting over here, walked in and said, "A second plane has hit the tower. America's under attack."*

The issue is that, on that morning, there was no footage of the first plane crashing into the building. Bush cannot have seen what he remembers. But our remembering self overhears our experiencing self and turns stories into memories.

WHERE DID I LEAVE MY FORGETTING CURVE?

―――――

What was the last TV show you watched? For me, the answer is Babylon Berlin, *an awesome German crime drama that takes place in Berlin in 1929 under the Weimar Republic— and the answer is also relatively easy because I watched it last night.*

If the question had been which TV show did you watch two months ago, or a year ago, the answer would have been harder to find and perhaps wrong.

We have an easier time remembering things that happened recently. One of the first to explore this phenomenon was Hermann Ebbinghaus, a German psychologist. Of course he was. How could he not be with that name—taste it—Hermann Ebbinghaus—he has to be a German psychologist.

Ebbinghaus discovered the forgetting curve by conducting a simple experiment on himself.

He studied his ability to remember nonsense syllables consisting of consonant-vowel-consonant combinations without meaning or association. So WID or ZOF could work, but DOT would not, as it is an actual word, and neither would BOL, as it sounds like "ball."

By the way, I think Ebbinghaus could have made a great management consultant. "Your KPIs in Q4 in the B2B portfolio are down. Must be the SEO, 'cause the CR has dropped and the CPC has increased by 30 percent."

Ebbinghaus would test his memory of these syllables again and again after various time periods and record the results. This was the 1880s, so there were not a lot of options in terms of entertainment.

Ebbinghaus was among the first scientists to perform actual experiments to understand how memory works. Prior to him, most contributions to the study of memory had been done by philosophers and had been speculation or observational descriptions. Ebbinghaus plotted the results of his ability to remember the syllables on a graph, creating what today is known as the "forgetting curve." The curve shows the decline of memory retention in time.

Hermann Ebbinghaus's forgetting curve

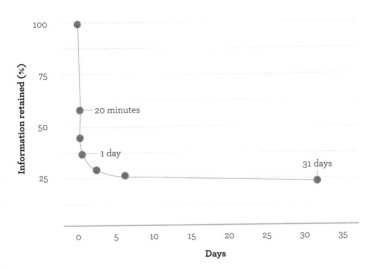

You can see how information is lost over time when there is no attempt to retain it. After twenty minutes, you lose around 40 percent, and after one day, around 70 percent of the information is lost.

HAPPY MEMORY TIP:
STAY AHEAD OF THE FORGETTING CURVE

*Help your kids and loved ones hold on to happy
memories by retelling happy anecdotes.*

Ebbinghaus made another discovery: we can alter the slope
of the forgetting curve if we repeat the learned information at
particular intervals. It is not just about repetition; there has to
be space between the reviews. It will not work if you repeat and
review something you want to remember twenty times in an
hour. If the fact is already in the front of your mind, there is no
work being done to enable you to recall it. You have to give your
brain a workout. If the information is retrieved at intervals, then
the brain has to reconstruct that memory, and this strengthens
it, like you strengthen a muscle by using it. Today, the principle
is known as "spaced repetition," where the material we want
to learn is reviewed and repeated after intervals of time that
become larger and larger.

I think all parents are interested in ensuring that their kids have
lasting happy memories—and helping them staying ahead of the
forgetting curve by retelling stories of happy experiences might
be a tool for that.

So when you want to hold on to happy memories and have your
kids hold on to happy times, one way could be to talk about them
that night, but also the next day, then a week later, a month later,
three months later, a year later.

PUPPIES AND NAPPIES

"What is the earliest thing you remember?"

For the past few years, I've been asking a lot of people that question. The answers have varied from getting a puppy to—as one of my friends, who shall remain nameless, admitted—having his nappy changed. My earliest memory is from the age of four. "How old are you?" my grandparents ask, and I cross my leg over the other to create the number four with my legs. I admit that, set against puppies and nappies, my earliest memory is relatively dull. Different studies of childhood memories reach different conclusions, but there seems to be some kind of consensus in the field of memory research that the earliest childhood memory is, on average, from the age of around three and a half.

That doesn't mean we don't remember things when we are younger than that. Katherine Nelson, a psychologist, was the first to explore early childhood episodic memory, in the eighties. She used a hidden tape recorder to document the things some children talk to themselves about when they are about to fall asleep—narratives from the crib. One girl, Emily, who was twenty-one months old at the time, would tell herself stories from the day. Car broke down. Had to ride in the green car. Clearly, this is episodic memory.

Some people say they remember being born, but there is little evidence that these are actual memories. Sigmund Freud introduced the concept of childhood or infantile amnesia to describe our inability to retrieve episodic memories from our very first years. In recent years, more studies have shed light on what kind of childhood memories are remembered.

One study from 2014 by Wells, Morrison and Conway, three British psychologists, published in the *Quarterly Journal of Experimental Psychology*, examined which details can be remembered in adult recollections of childhood memories.

A hundred and twenty-four people took part in the experiment and were instructed to write about two positive and two negative earliest childhood memories—in total, 496 memories. The participants were asked about nine details concerning the different memories: Who was present? Where did it take place? What was the weather like? What were you wearing? And so on. They were instructed not to guess but to answer only if they believed they remembered the detail.

People were able to remember more details from positive than from negative memories: on average, 4.84 details out of 9 from the good stuff versus 4.56 details from the bad stuff. Most people (85 percent) could remember where the memory took place, half could remember how old they were at the time, but only 10 percent could remember what they were wearing.

Eighteen percent of the positive memories centered around achievements—for example, learning to ride a bike—13 percent were about birthdays and Christmases and getting presents, and 10 percent were about trips and holidays.

The negative memories typically concerned illnesses or, for example, breaking a leg (25 percent), being scared or being bullied (14 percent), and death, either of a family member or a pet (11 percent).

I think the take-home message from the studies on childhood memories is that evidence suggests that our memories are linked to our language ability, that is, our memories start staying with us at the time we begin to be able to tell stories about our life—and, therefore, we can shape our memories by choosing which stories to tell and by choosing which activities are likely to yield fond childhood memories for our children.

Your children may forget their own earliest happy memories. So even though it is their happy memory, maybe you can hold on to it for a while and give it back to them when they are old enough to carry it forward.

On average, **4.84** details out of **9** from the good stuff versus

4.56 details from the bad stuff

EMBRACING THE ROLE
OF MEMORY ARCHITECT

Some of my happiest childhood memories take place in the landscape around the cabin my family and I lived in from May to September each year.

In June, the nights were blue and bonfires lit up along the coast. In the forest, we would climb trees and search for berries. In the hills, we would explore fox tunnels and look for hidden Nazi gold. In the fields, we would "help" drive the tractors and build houses from bales of hay. By the streams, we would fish and build dams. By the beach, we would swim and, if we got cold, we would dig our way under the small boats turned upside down to keep warm.

The smell of hay, the taste of raspberries and the warmth of a wooden boat that has been soaking up heat all day still take me back to those days. Those were simple times. Those were happy times.

And I am not alone: simple pastimes such as climbing trees and running around barefoot outside in the summertime until dark are also among the most treasured childhood memories in Britain.

In 2016, a survey commissioned by New Covent Garden Soup collected answers from 2,000 adults and the results revealed the most typical childhood memories in Britain: 73 percent said the beach played a part in their happiest memories. In addition, according to the study, our childhood memories are ten times more likely to be from events that took place in the summer, compared to the other seasons.

Furthermore, it seems that we are keen on having our children enjoy the same happy memories by experiencing the same happy times we did. More than half of parents surveyed said they have visited a destination with their own family they visited themselves as a child in an attempt to re-create fond memories.

THE FIFTY MOST COMMON CHILDHOOD MEMORIES

1. Family holidays

2. Hide and seek

3. Collecting shells on the beach

4. Hopscotch

5. Watching *Top of the Pops*

6. Sports days

7. Watching children's TV

8. Fish and chips

9. Pic 'n' mix sweets

10. Playground games (British bulldog, etc.)

11. Pencil cases

12. Climbing trees

13. Egg-and-spoon races

14. Recording the music charts on a Sunday

15. School dinners

16. Collecting toys/cards/etc.

17. Ice creams from the ice cream van

18. Playing outside until it was dark

19. Paddling in the sea

20. Dinner ladies

21. Your teeth falling out and putting them under your pillow

22. Kiss chase

23. Fighting with siblings

24. Fishing for tadpoles in a pond

25. Going to Woolworths to buy records

26. Playing on a rope swing in the woods

27. School field trips

28. Visiting cousins

29. Making daisy chains and wearing them around your head

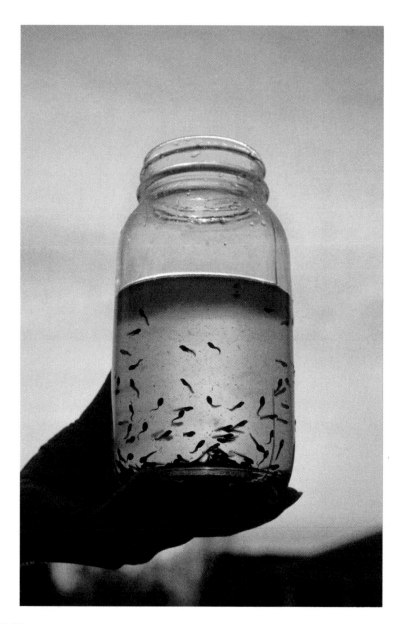

30. Going back-to-school shopping at the end of the summer holiday

31. Getting up really early in the morning to go on holiday

32. Reading magazines

33. Exploring rock pools

34. Using jumpers for goal posts

35. School tuck shop

36. Playing in the paddling pool

37. Ice cream floats

38. Running around barefoot outside

39. Sleepovers with friends

40. School packed lunches

41. Swimming in a cold sea

42. Playing tennis against the back of the house

43. Scratch-and-sniff stickers

44. First time getting told off by a teacher

45. Staying up late for New Year's parties

46. Sliding on the grass in school uniform

47. Paper rounds

48. Going camping

49. Playing games on long car journeys

50. Singing in the back of the car

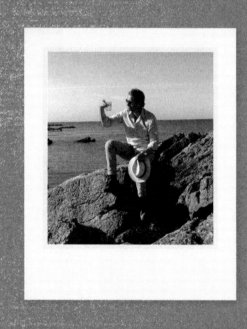

HAPPY MEMORY TIP:
RENAME PLACES WITH MEMORIES

Combine autobiographical and spatial memory.

Spatial memory records information about our environment and spatial orientation and makes us able to navigate around a familiar city. It helps us remember where an object is located and has helped us survive as a species. Nuts are found here, fresh water there. These days it's "The coffee's there, and there's the power socket for my phone." But the principle is the same. Finding one's way around is crucial in everyday life and you are likely to be better at it than remembering names at parties.

You may be able to use your great spatial memory to your advantage to hold on to happy memories. The idea is simple: rename places. If a certain place was the scene of a happy memory, start referring to that place by the happy memory.

Every summer, I go to the island of Bornholm, a beautiful rock island in the Baltic Sea. I have a tiny cabin there and the areas around the cabin have been the scene of many fond memories. Many of them have to do with foraging. There's the Wild Cherry Forest, Juniper Lane, Elderflower Gorge, Raspberry Fortress, Spearfishing Bay and Skinny-dip Cove.

Some of these places have official names. Raspberry Fortress is in fact called Lilleborg and consists of the ruins of a twelfth-century Viking keep, but that name would not remind me of a wonderful afternoon eating raspberries—or where to get raspberries the following summer.

CHAPTER VIII

OUTSOURCE MEMORY

There is a website called The Burning House, and it's a collection of pictures of things people around the world would save if their house was on fire. It allows a wonderful peek into the human mind and heart. What are our most treasured possessions?

Diaries, letters from Grandma before she died, scrapbooks, Marilyn Monroe's autograph, a mixtape from my aunt, my grandfather's old nautical compass, a doll containing a secret from my best friend, Nutella and a bottle of Jack Daniels.

The answers are diverse and sometimes reveal a conflict between what's materially valuable and what's of purely sentimental value. But there is one common denominator that runs across the answers. The most common thing people would take out of their burning house is their photo albums.

I am no different. I see photos as the key to a vault of memories. If the key was lost, I fear that the memories would be sealed off forever.

This year, I brought home a collection of photo albums—photos from my childhood which my brother and I packed up after our mother died, photos I hadn't seen in twenty years.

They bear witness to how time has passed: the eighties, the dungarees, phones with a rotary dial . . .

The photos are not of great quality. Nor were they taken by master photographers. My mother had a special gift for cropping half the face outside the frame.

But the photos are full of association triggers. As I see them, memories resurface, or snapshots of emotions, then a whole range of other connections start to be made.

There is a picture of our dog, Pussy (I know it was a weird name for a dog, okay)—and I remember the time she fell through the ice and my dad rescued her.

I see a picture of me on my first bicycle—and I remember my first accident, riding straight into a rubbish bin.

I see a picture with my mother's golden Volkswagen Beetle in the background—and I remember how she always left her keys inside and that, by the age of ten, I had learned to pick the lock with a wire.

I see a picture of me reading with my grandpa in the lounge chair—my favorite place to read in our summer cabin—and I remember reading Astrid Lindgren and Tintin books under the blanket and planning my own adventures there.

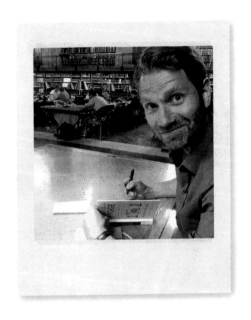

I look at the pictures and feel grateful for every time someone pressed down on the shutter.

These pictures remind me of some of the happiest moments in my life. I realize that maybe this is why I enjoy photography so much—it's the same reason I enjoy being a happiness researcher. My job is to make the unmeasurable measurable. In my spare time, I have tried to preserve the unpreservable. My work and my hobby are both attempts to capture this elusive thing we call happiness. To ask time to freeze. To allow us to savour those moments when all felt right in the world. It has been an attempt to preserve happiness for that $^{1}/_{250}$th of a second.

And I am not alone. When we asked people in our Happy Memory Study why they remembered a specific memory, 7 percent said that they had some sort of memento from the event—for instance, a photograph. Each year, humans take more than a trillion photos. A trillion is a thousand billion—I had to look it up. It is no wonder that we sometimes feel that we are drowning in snapshots of other people's lives. I think the number is best visualized by an exhibition by Dutch artist Erik Kessels in which he printed out 350,000 photographs from Flickr—the number shared in one day—and placed them in a gallery.

7% of people in the Happy Memory Study remembered their happy memory by using a memento

Humans take more than a **trillion** photos a year

Most of our photos these days remain in the cloud, on drives, inside apps or on social media and never make it into print. Browsing old school photo albums has been almost completely replaced by scrolling through Instagram and Facebook.

On Thursdays and Fridays, my feed is flooded with #tbt and #fbf—also known as Throwback Thursdays and Flashback Fridays. Taking it one step further is Timehop, described as #tbt every day. Here, users' social media posts and pictures from the same day from several years are pulled together in a time capsule that can be shared with others. Timehop's motto is "Celebrate your best memories every day" and their goal is to reinvent reminiscing and help people find new ways to connect with each other around the past.

The fact that we are outsourcing our memory to the internet makes things even more complicated. The Instagram generation are not only their own PR managers; they are also architects of their future memories. However, we also risk digital amnesia through losing our precious photographs and messages along with our phone or laptop. Studies also show that, if we think we can re-find a fact online later, we are less likely to commit it to memory in the first place.

One study by Ian Robertson, a professor of neuropsychology based at Trinity College Dublin, conducted with 3,000 Britons found that a third of those under the age of thirty were unable to recall their telephone number without using their phone. The study was published in 2007 and we certainly haven't become less dependent on our devices since then.

HAPPY MEMORY TIP:
YOUR OWN PERSONAL GLIMPSES
OF HAPPINESS

Consider having a private social media account as a memory bank.

Your social media account can be great for a trip down memory lane. Your photos, videos and thoughts in chronological order—a mixed-media memoir of sorts. The trouble is, you might edit out anything that is not suitable for Instagram. The debate on curation versus authenticity is ongoing, as people often find that Instagram is one long feed of picture-perfect curated lives. Personally, I try to balance highlights with the everyday and ask people to note that "Photos posted on my Instagram and Facebook are highlights from my life and not my usual life. Most days are spent spilling coffee, installing software and looking for my keys." In addition, there are a lot of things that mean a lot to me but are completely irrelevant to people I am connected with online.

One solution could be to create a private account for whenever you want to take a stroll down memory lane—a museum for your memories of the everyday. You may find it quite liberating to snap and post photos that are for your eyes only. No need to worry about the right filter, lighting or caption.

Instead of being the curator of how other people see you, try to be the curator of how your future self can look back. When your future self would like to take a walk down memory lane, what are the things they would like to see?

It means taking pictures of your everyday life. Of everyday objects that might not seem memorable now but will be immensely fun to look at twenty, thirty or forty years from now. The background in some of the pictures from my childhood in the eighties and nineties yields curiosities like rotary-dial phones, enormous computers and deep-pan TVs.

LIFE LOGGING—THE ERA OF TOTAL RECALL AND DIGITAL AMNESIA

Imagine you could pull out an archive for any day in your life and re-experience that day. What you did. Who you met. What you ate for lunch.

Would you like that power? Sure, it would be nice to re-watch your wedding, parties and accomplishments—and find out exactly where you stepped in that thing you brought on to the carpet of the Ministry of Foreign Affairs—but maybe there are plenty of things we would rather forget.

But if you are Gordon Bell, you have the opportunity to travel in time. In 1998, Gordon Bell, a researcher at Microsoft, began collecting as much digital information about his life as possible. Bell also headed a research experiment named MyLifeBits at Microsoft—a foundation for the modern version of the Quantified Self movement and fitness trackers such as Fitbit. Think of him as a more systematic and digital version of Andy Warhol.

Photographs and videos went into a searchable archive of Bell's memories—but also his heart rate, temperature, emails he received and websites he visited. The MyLifeBits project includes more than 1,000 videos, more than 5,000 sound files, including conversations, tens of thousands of photographs, more than 100,000 emails, every text-message exchange and every webpage he has visited. Gordon Bell wrote a book about the whole thing: *Total Recall.* Great title.

Gordon might be extreme, but he is not alone. People around the world are keeping photo journals, counting their steps and logging their lives.

Furthermore, life logging is not a new thing. We used to call it keeping a diary. But a new breed of apps and gadgets is taking it to a new level of details and vividness. A wide selection of life-logging cameras capture moments throughout the day.

Some are worn around the neck and can shoot up to 2,000 photos per day, while others shoot two photos a minute and tag where they were taken using a built-in GPS.

Through our devices and social media accounts, we store mountains of details from our lives, but we never seem to organize them. As I see it, the problem is not the lack of collecting but the lack of curating and preserving.

Our digital libraries are a total mess. We store photos—but we seldom see them. We get crushed under our own big data. To make matters worse, we not only suffer from this photo fatigue but also risk digital amnesia. Because, contrary to what many people think, digital records are often more difficult to preserve than traditional print records.

Twelve years ago I attended a wedding in Siena. It was stunning. There were ladies in big hats and gentlemen in flax suits. We spent a week there in a villa outside the town, having dinner at long tables and going for walks in the hills.

I must have taken a thousand pictures that week. They are all gone. I am not sure when or how. They were on a camera. They were on a computer. One was stolen. One broke down. One hundred years after the lost generation, we see a generation of lost memories.

That is a real contrast to the experience I had this year with old school photographs. The photo albums I had not seen in twenty years were still there. Faded, yes. Cropped faces, yes. But they were there. I have now started to print out the digital shots recording the moments that are most meaningful to me.

MEMORY — THE ARTIST

We share stories with our loved ones. We share memories and we pass memories back and forth. Outsource them. Lend them out. Borrow them. In the process, they are polished and altered.

In 1985, my family and I were on holiday in what was then Yugoslavia. We drove there from Denmark and it took two days. We had one cassette tape. Whitney Houston wanted to dance with somebody all the way across Europe.

During the trip, we visited a stud farm. I think they bred racehorses. However, they also had a small donkey there and we—my brother and I— got to ride it. It was stubborn and lazy and preferred to eat grass instead of walking around with tourists on its back. I have a vivid memory of that donkey and can still feel its coarse hair.

Thirty years later, I was going through the old photo album—the album I hadn't seen in twenty years. It turned out there was no donkey. It was a small white horse. I had a clear memory of riding on a donkey—but here was clear evidence that my memory was false.

In Danish, as in many other cultures, a donkey is thought of as stubborn. You can be "as stubborn as a donkey." What is likely to have happened is that the story of the stubborn horse that was told in our family had over the years morphed the horse into a donkey because of semantics and our faulty memories.

Memory is not only the museum curator—it is also the artist. It not only chooses pieces of art to exhibit but also paints them and paints over them. Sometimes, it is like the Impressionists, sometimes like the Expressionists, and sometimes like Dalí on LSD.

People mistakenly think of memory as being like a camera or a filing cabinet. If you want to remember something, you can search for the file and look it up. But that is not how memories work. A memory is not a thing, it is a process. Memories are mental constructions, re-created in the here and now, based on what your demands of the present are. When you piece the details together, some belong to the event itself and some may have been added later. There is no mental YouTube where your experiences are stored in perfect condition and can be replayed in the original version. Every time you play it, you alter it a little bit.

"Do you remember getting lost in the shopping center?"

"No, I don't think so," you say.

"Here is the description of the event your parents gave us," says the researcher conducting the experiment, and she passes you a piece of paper. You read their story of the event. You were three at the time. You got separated from your parents in the busy shopping centre but an old lady saw you crying and helped you.

"Do you remember that? Do you remember how you felt?"

You think for a moment. "I was scared," you say. "I couldn't see my parents."

"What did you do?"

"I think the nice old lady helped me—and then they called my parents over the PA."

"Can you remember what she looked like?"

"I don't know—I think maybe she had glasses. And a green dress."

Here's Elizabeth Loftus again, with another study on faulty memory. She and her colleagues presented twenty-four participants with four stories from when they were between four and six years old. The participants thought the experiment was about their ability to recall details of their childhood memories. That was a lie. It was a study examining the possibility of implanting false memories.

Three of the four stories the participants were presented with were true— the researchers had interviewed their relatives. But one of the four stories was false: the lost-in-the-shopping-center memory. It seemed a likely story—the researchers asked the relatives which shopping center they used to go to—but the relatives had also confirmed that the event had in fact never happened.

Soon afterwards, the participants were interviewed. At this point, they were reminded about the four memories and asked to recall as much as they could about them. At a second interview a week later, a similar procedure was followed. At the end of both interviews participants rated the clarity of their memories.

At the end of the experiment it was revealed to the participants that one of the memories was false and they were asked which one they thought it was. Of the twenty-four, five did not pick the lost-in-the-shopping-center memory and so believed it was a real memory.

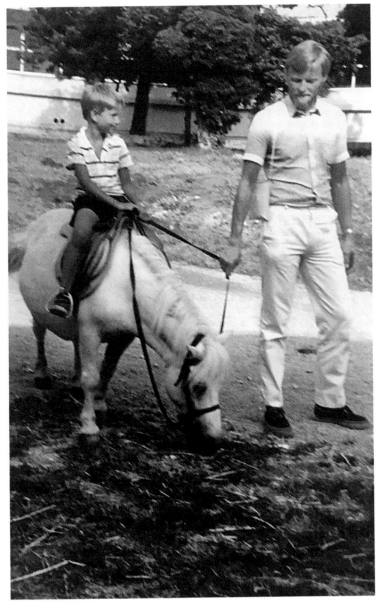

INSTAGRAM MEMORIES

*At the time of writing, there are more than 8 million posts
on Instagram with the hashtag #makingmemories and more
than 70 million just with #memories. There are also more
than 17,000 posts with #memoriess, so even people who
can't remember how "memories" is spelled post about them.*

At the Happiness Research Institute, we ran an analysis of Instagram
posts with the #makingmemories hashtag. We randomized the photos we
selected to make sure we did not have time-zone biases or seasonal biases
and we excluded photos posted by companies or which had a commercial
purpose. However, the analysis does include a language bias, as we only
included posts in English. So if we ran the study in Danish or Russian, it
might look different.

So, what are people doing when they say they are making memories?
Well, the analysis shows that the memories people post with the
#makingmemories hashtag fall into roughly four categories.

First, there is the #momlife-dadlife-familylife category. Kids being cute.
Kids playing in the snow. Kids making a mess in the kitchen. The carved
pumpkins, the Christmas trees and the trip to Disneyland. Second, there
is the #SassyPOTD (Post of the Day) category. Girls' night out. Boys'
night out. Friendships, BBFs and squad goals. Cocktails and shots and
things that seemed like a good idea at the time. Third, there is the #Love
category. Weddings and anniversaries. Getaways and long weekends.
Couples smiling at the camera. Also known as the "look what I've caught"
category. But the lion's share of posts falls into the fourth category—the
#Wanderlust category. The holidays. The discoveries. The adventures.

365happydays vacation

beauty sassyPOTD life

wine exploring

travelgram family spring smiles

makingmemories

happiness skiing discover

pictureoftheday

winter

BBFs hiking

friends

Wanderlust

momlife future sunset

sunset

bestdays

baby

squadgoals love

autumn outdoors

adventure laugh holiday

summer beach yum

dadlife

It is the mountains we climbed, the cities we explored and the sunsets we chased. New Zealand, New York and new horizons. Memories are made when our wanderlust is unleashed. When we're travelers. When we're explorers. When we're adventurers.

Memories are made when we tread in the footsteps of the David Livingstones, the Marco Polos and the Vasco da Gamas. When we set sail, take off or lace up our hiking boots. When we hunt for treasure—and that treasure is a memorable life.

Making memories is to embrace the travel-often mantra. You can always make money—you can't always make memories.

HAPPY MEMORY TIP:
HAPPY WHIFF LISTS, SOUNDTRACKS, DATA POINTS

Get creative with outsourcing.

Outsourcing your memory does not have to be done via photographs. If you have kids, you may also get them to draw a happy memory of something you experienced together. If they have a talent for music or rhymes, they may enjoy writing a song. Or do as my wonderful editor, Emily, does, and create a playlist on Spotify for each month. She has done this for the past few years and enjoys listening back to a random month.

Since all our senses can trigger memories, you may want to go Warhol on the scent front and create a happy whiff list. Pair scents with happy memories. One woman I spoke to recently bought a special perfume for her wedding and wore it only on her wedding day. What I have also started to do is to record sounds from moments where I have been happy. I have recordings of the waves hitting the rocks on Bornholm, the wind in the leaves from a tree in former royal hunting grounds north of Copenhagen and the sound of the wind in the wires of sailboats in Split harbour in Croatia.

Or you may want to take your lead and inspiration from Alejandro Cencerrado Rubio. He is one of my amazing colleagues at the Happiness Research Institute and works as a data analyst.

Alejandro *loves* big data sets and he is responsible for a lot of the exciting findings that come out of the Happiness Research Institute. In fact, when it comes to finding happiness, I think we are all searching for the same things: we all want to find somebody who looks at us the way Alejandro looks at data.

In addition, for more than thirteen years Alejandro has been collecting his own happiness data. Every day, he records a happiness score from 1 to 10. Has this day been a good day? What have I been doing? How happy have I felt? Would I like to repeat this day another day?

Here's his entry from 25 February 2017, a Saturday:

Today I'm in one of those days that give meaning to life. I've come from being with Mamen, our first date, and I know she's the girl I'll be with for a long time. I know it by the way she laughed, by how she looked at me, by how the conversation flowed. I am at home with the rain bumping into the glass, in the loneliness that has been chasing me for so many years, and to think that out there is someone who can get me out of this loneliness makes me feel something special, as if the lonely Alex who has lived here up to now is something from the past. The scenes that remain in my memory, with the candlelight reflecting in her eyes, looking at me, totally focused on them. I couldn't tell if I spoke loudly or lazily, if someone looked at us, because

I only had my mind on the conversation, not believing a girl like that could like me at all, but knowing that her gestures were obvious; what a pity not to be able to transmit emotions like those of today with a few words, but how real and genuine it is, that only a few times in life you can experience something like this, the casual union of two people who understand each other and like each other without doubt. I don't know how to name what I am feeling, I think I'll call it illusion, it's not happiness, because I still don't know if she likes me, if I'm someone for her, but it's a promise of happiness, a promise to stop being alone, of not having to look for more. As a detail, it surprises me that photos of landscapes that I don't usually find very striking, today I look at them with a special sense. I imagine myself there with Mamen, embraced, united, fused, loving. Thunder seems to me to have so much beauty, it is impressive the sense that a single date with a girl that I like and pay attention to gives life.

That day was a 6.

By the way, Mamen did like Alejandro. They are getting married this year.

Combining the data for each day with a description of each day enables him to understand what happens on his happy days. What Alejandro finds is that the best days are about connection—connecting with our loved ones. They're about friends, family and romantic love. About feeling special.

I think one of the coolest things about Alejandro's data set is that he enables the experiencing self to be heard in the present. How we remember something is one thing, but another thing is how we actually experienced it. For instance, Alejandro might think back to his trip to Indonesia and remember the sandy beaches, but if he goes back and examines the data for those dates, he finds that his experiencing self was troubled by the heat and the mosquitos. If you understand Spanish, you can follow Alejandro's blog at 11anhosymedio.blogspot.com You may also take inspiration from Alejandro and consider alternative ways of making a diary. It doesn't have to be data—I've seen someone who has recorded a second each day for the past years to create a beautiful video montage.

THE PERFECT
META-MEMORABILIA

Imagine you are presenting your new book about making memories to a group of journalists.

There are a lot of other speakers presenting their new, exciting books and you want to ensure that the audience remembers you. Then you remember the pineapple principle. Bring something on stage that will grab their attention and stick in their memory. You look around the hotel room. There is a small statue of the head of a horse. It is perfect. You take the statue on stage and your speech goes well. You see how your words resonate with the audience. Their faces light up. They nod. They laugh. You're talking about how to make our lives unforgettable by making moments memorable and you realize that this is one of those moments. This moment will be a memory. A memory in the making about the book about making memories. It's very meta. You bring the statue back to the hotel and you realize that the statue is now the manifestation of the meta-memory experience. You realize that this statue is a perfect example of meta-memorabilia. I am not saying that you took the statue. Just because you might have Viking blood in your veins, it doesn't mean you can't visit the UK without looting. Pillaging is so ninth century. Twenty-first-century Vikings are all about equality and wealth distribution. They would take the statue from the fancy hotel, leave a £200 tip for the maid and a note suggesting that the money should be spent on making memories. Hypothetically speaking, of course.

HAPPY MEMORY TIP:
USE MEMO SNAPS

Create and use acronyms to help you remember.

Singing and rhymes help children to learn the alphabet—and we can add acronyms as mnemonic tools for learning. For instance, to remember the North American Great Lakes of Huron, Ontario, Michigan, Eerie and Superior, the acronym HOMES may be useful.

Or, if you want to memorize the names and order of the planets Mercury, Venus, Earth, Mars, Jupiter, Saturn, Uranus and Neptune, you could use a phrase like "My Very Educated Mother Just Served Us Nachos" or, if you don't want to leave Pluto out in the planetary cold, "My Very Educated Mother Just Served Us Nine Pizzas."

You can also harness the power of acronyms and use memo snaps when thinking about how to create memories and hold on to them. Memo snaps.

Multisensory, Emotional, Meaningful, Outsource, Stories, Novel, Attention, Peak and Struggles—or you can also go with an anagram like Aspen moms, Omen spasm or Mensa poms. Whatever rocks your boat.

CONCLUSION:
THE PAST HAS
A BRIGHT FUTURE

———

Sharing our past with someone is an ingredient in the recipe for falling in love.

In 1996, Arthur Aron, professor in psychology at Stony Brook University, New York, came up with thirty-six questions that create intimacy between strangers—questions that would make people fall in love. Several of the questions revolve around our memories:

- What is your most treasured memory?

- What is your most terrible memory?

- Tell your life story in as much detail as possible in four minutes . . .

- What is the greatest accomplishment of your life?

- If you could change anything about the way you were raised, what would it be?

- Share an embarrassing moment in your life . . .

- Do you feel your childhood was happier than most other people's childhood?

Knowing about the worst and best things that have happened to someone else is a way to create intimacy. Sharing our greatest accomplishments and worst embarrassments connects us. Sharing our life narratives allows us to see the world with each other's eyes. According to the inventor of the questions, "one key pattern associated with the development of close relationships among peers is sustained, escalating, reciprocal, personal self-disclosure." The idea is that mutual vulnerability creates closeness.

Keeping this in mind, it was interesting to read through people's memories in our Happy Memory Study. Despite each memory being a snapshot from the life of a stranger, I did feel I got to know them a little bit. I felt connected to them because so many of their stories resonated with me. I understand why that night on the frozen lake was so much fun. I understand how eating raw porridge on a windy beach brought you closer together. I understand how meaningful it felt to walk with your little niece after your grandmother's funeral.

To me, that is another testimony of how alike we all are. When it comes to what brings us happiness—and what happy memories are made of—we might be Danish or British, American or Chinese, but we are, first and foremost, human. We all have things we want to remember, and we all have things we want to forget.

To me, one of the most important things I learned in researching and writing this book is how amazing memories are. Not only do they allow us to travel back in time, to look ahead into the future and impact on how we feel right now, they also enable us to connect with ourselves over time and to connect with other people. But memories can also be a burden that we carry around with us. Not every memory is a happy one.

THE ART OF LETTING GO — WHY TOO MUCH PAST IS PARALYZING

In the film Eternal Sunshine of the Spotless Mind two former lovers undergo a procedure to delete their memories of their romantic but painful relationship.

We all have things we would like to forget, but we also have the awareness that our memories—even the bad ones—are what make us who we are. In addition, some of us may also dream of having a perfect memory—to be able to remember everything we ever heard, read or experienced. However, we also need to be aware of the downside of a perfect memory.

What did you do on January 10, 1981? If you were not born then, how about January 10, 1991, or 2001? What was the weather like? What day of the week was it? What happened in the news? If you are like me, you have no idea. Well, if it was January 10, 1981, guessing that Copenhagen was cold and dark is a safe bet. And I was three, so I probably had a jam-packed schedule of eating, crying and drooling.

But if you are like Jill Price, you may remember that on January 10, 1981 a guerrilla war was launched against the government in El Salvador which would last for eleven years. Jill was driving a car. For the third time. Driving lessons at Teen Auto. She was fifteen. It was a Saturday.

Jill is one of the very few people in the world with Highly Superior Autobiographical Memory (HSAM), also known as hyperthymesia. She can recall every day of her life since she was fourteen years old.

Jill, an American woman living in California, was the first person in the world to be diagnosed with hyperthymesia. It means that Jill experiences continuous automatic playback of events from her life. "Give me the day and I see it. I go back to the day—I just see the day and what I was doing," she writes. She has been studied by researchers for years. One of them is James McGaugh, a research professor in neurobiology and behavior at the University of California, Irvine. Professor McGaugh and his colleagues have discovered that Jill is not alone. However, fewer than a hundred people globally have been diagnosed with the condition.

In her book, *The Woman Who Can't Forget: The Extraordinary Story of Living with the Most Remarkable Memory Known to Science*, Jill describes her memories as being like scenes from home movies, relentlessly playing over and over again, flashing forwards and backwards—short scenes on constant shuffle mode.

Jill's story shows that memories can be both a blessing and a curse. She enjoys having a storehouse of memories she can travel to for comfort, but that storehouse of memories can also become a prison. This seems to echo the experiences of other people with HSAM.

Well before the world learned about people with hyperthymesia, Jorge Luis Borges wrote about the phenomenon. Borges often writes about philosophical concepts and, in the 1942 story "Funes, the Memorious," he explores the consequences of a perfect memory. In it, you meet Funes, who can remember the shape of the clouds in the south on April 30, the marbled grain of a leather-bound book he saw once and the pattern of the water spray from an oar during the Battle of Quebracho Herrado. In short, Funes has a pretty good memory.

Funes is forced to spend his days in a dark room which doesn't offer any sensory impressions. When Funes recalls the events of the previous day, his memory is so complete that it takes a full twenty-four hours to do so. In addition, the memories become compounded by the recollection of recollection of a recollection. Funes not only remembers every leaf on every tree in every wood but also every time he ever thought of every leaf on every tree in every wood.

At the end of the story, Funes is no longer capable of processing all the details of his memory. It is not a happy story, but it does give the reader an insight into the downsides of a perfect memory.

Our memory is at best—in the words of Virginia Woolf in her memoir—a sketch of the past. But despite being faulty, despite the fact that our memory is biased by peaks and ends, it is still worth something. And maybe our happiness depends not only on what we can remember but also on what we are able to forget. Too much past can be paralyzing. We want to hold on to our happy memories, but we also want to be able to let go of the past, to live in the present and plan for the future.

A SKETCH OF THE FUTURE

Imagine a ladder with steps numbered from 0 at the bottom to 10 at the top. The top of the ladder represents the best possible life for you; the bottom of the ladder represents the worst possible life for you.

On which step of the ladder would you say you personally stand at this time?

And which step on the ladder do you think you'll be at in five years?

If you are like most people, you are likely to give a higher number to the second question than the first. People are optimists. We expect to be happier in the future than we are today.

In 2018, Angus Deaton, a Nobel Prize-winning economist, published a paper examining the answers to these two questions given by 1.7 million people from 166 countries collected between 2006 and 2016 in the Gallup World Poll.

Deaton found worldwide optimism. Across regions of the world, we are optimistic, but some are more optimistic than others. Looking at the data from Denmark, we can see that people living in the bigger cities are more optimistic: people in Copenhagen and Aarhus believe that life five years from now will be far better than it is today, whereas people in rural areas are more likely to think that life in five years will be pretty much like life is today.

In part, this has to do with another finding of Deaton's, which is that younger people are more optimistic about the future. Because there are universities in Copenhagen and Aarhus, there is a greater concentration of younger people in these cities. When comparing their happiness now with their expected happiness five years from now, younger people expect to make a bigger leap. Those aged between fifteen and twenty-four have an average happiness level of 5.5 on a scale from 0 to 10 but expect to achieve a happiness level of 7.2 five years from now. That is a difference of 31 percent—great expectations.

Optimism is wonderful. Expecting or hoping to be happier in the future is wonderful. However, I think the important question is how to get to that happier time. As I mentioned, our episodic memory is our ability to travel in time. We have explored going back in time, but we can also travel forward. fMRI studies indicate that thinking about the past and thinking about the future activate the same areas of the frontal and temporal lobes in the brain. Harvard psychologist Daniel Schacter is one of the researchers looking into this, and he writes that the brain is "fundamentally a prospective organ that is designed to use information from the past and present to generate predictions about the future. Memory can be thought of as a tool used by the prospective brain to generate simulations of possible future events." So we can use happy memories from the past to plan for happy experiences in the future.

How would you like to make deposits in the happy memory bank? How would you create days you will remember forever? By now, I hope you have some ideas in the category of anticipatory nostalgia. So let's start planning.

PLANNING A HAPPY AND MEMORABLE YEAR

Remember that the best part of memories is making them and, although more happy memories seem to stem from summertime, it is possible to make memorable moments all year around.

Here's a selection of ideas of how to plan for happy memories throughout the year.

JANUARY:
PLAN FOR ASSOCIATION BY DAYS

If there is no clear association between certain things, it makes it more difficult for us to remember them. For instance, March 14—what did you do on that day? If you are like me, nothing comes to mind. But then I look it up, and March 14 was the date of the European release of the World Happiness Report, which took place in the Vatican—and then I remember a lot of details from that day. I remember where I had breakfast, lunch and dinner. I remember walking around in the Vatican Gardens with a group of happiness researchers and that we saw turtles in the fountains. I remember Andrea Illy from the coffee company pointing out that the happiest countries in the world are also the biggest consumers of coffee.

So use January to consider how you can use:

International Day of Happiness (March 20), World Poetry Day and World Forest Day (March 21), World Water Day (March 22), International Jazz Day (April 30), World Migratory Bird Day (I imagine the non-migratory birds are quite pissed off; second Saturday of May), Global Day of Parents (June 1), World Bicycle Day (June 3), International Day of Yoga (June 21), International Day of Friendship (July 30), International Day of Older Persons (October 1), World Teachers Day (October 5), World Science Day (November 10), World Soil Day (December 5) and International Mountain Day (cancelled in Denmark and The Netherlands; December 11).

For example, you could organize a bicycle trip for friends or family on World Bicycle Day. It's in June so, in many parts of the world, you may have perfect weather for it. If you're in the southern hemisphere, planting a tree on World Soil Day might be a nice memory. Or you could try yoga on International Day of Yoga—remember: firsts are more memorable; I still remember my first yoga class. When the instructor asked us to stretch our legs and put the palms of our hands under our feet, she looked at me and said, "Or just see how far down your shins you can reach."

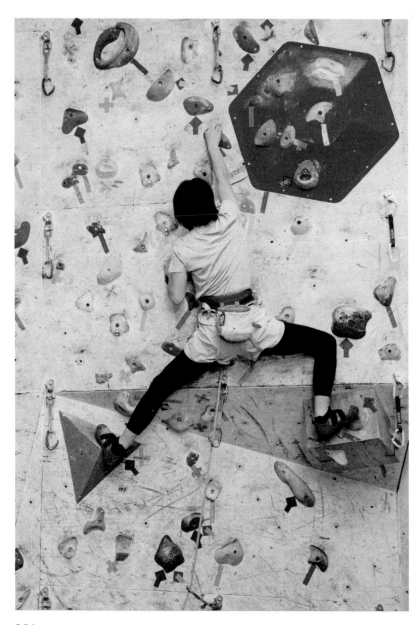

FEBRUARY:
FACE YOUR FEARS

One of the happy memories we collected in our study was from a woman from Belgium who remembered the night she went on stage even though she was scared to perform in front of a crowd. I can relate to that. In 8th grade (so I was about thirteen), my class performed a Christmas play for the entire school. I was elf number 13—a very important role. I had one line: "There is someone in the workshop!" I still remember the line today, in part because we rehearsed a lot and in part because I—like most people—used to suffer from glossophobia, fear of public speaking, making it a fearful experience.

But facing and overcoming our fears is one of the ways we can apply the emotional highlighter pen to making memories. So face your fears, sign up for the rock-climbing course, the French class or the open-mic night and take the stage. Remember to bring a pineapple.

MARCH:
MAKE IT MEMORABLE

A happy life is a purposeful life. As we saw earlier, meaningful moments matter when it comes to our memory. Spend the month of March taking steps to increase the level of connection you have with people. It may be little things like doing something important for a loved one, or you may want to send a letter of gratitude to those people who have helped you along the way. Those letters are likely to show up in the memories of those who received them when we conduct our next Happy Memory Study.

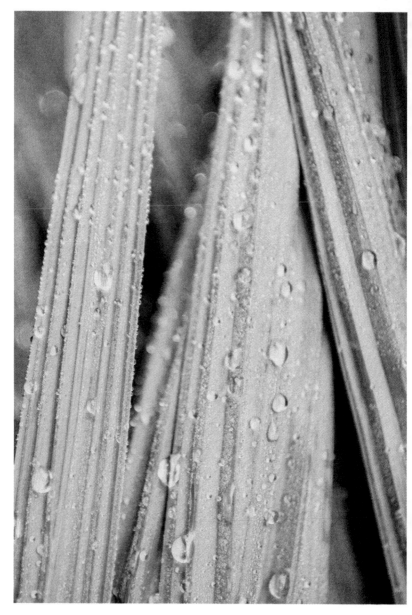

APRIL:
PAY ATTENTION TO HAPPINESS

What are the things that bring you happiness? We have seen that memory requires attention. We remember the things we pay attention to. So it is important to consider—and pay attention to—the things which affect our happiness. Usually, five weeks will fall in April. While one or two of them might be short weeks, it nevertheless provides you with a structure to dedicate one week to each of your five senses. What sounds, sights, smells, touches and tastes bring you happiness? The smell of a freshly opened bag of coffee? The way soft rainwater feels on your skin on a warm spring day? The sound of your children or your best friend laughing? Try and really pay attention and note how they laugh. If you were to play them in a movie, how would you imitate their laugh? You may want to write these things down. That way, you can also see changes in the things that bring you happiness and so create a catalog of things which bring you happiness if you need inspiration for what to do at the weekend.

This exercise might also work as a gratitude journal—something we often see the effect of in happiness research. Studies also show that it is better to do this occasionally and not necessarily every day, to keep it from becoming a routine.

MAY:

MAKE PLANS FOR MEMORABLE MOMENTS

Remember to plan for memorable experiences. What dreams do you have for next year? What in your future do you want to look back at and smile? Now might be the right time to start planning and making it happen.

One of the dreams I have for 2020 is to gather a group of fellow writers for a writers' retreat. I am talking renting a big-ass villa in Italy. We will write during the day, go for hikes in the afternoon and have dinners at a long table in the evenings. Oh, and there will be wine.

That is something I would love to make happen. "Whatever can happen will happen" is sometimes known as Murphy's Law and, while it might be a good strategy for risk management, it is a lousy strategy for dream management.

So use May to turn "maybe" into "will be." Break down your dream for next year into steps and get cracking on the first one towards making it happen. For my dream, the first step was to find a suitable villa that was available for rent, and I've found one on a hill close to Poppiano, about an hour from Florence. It is an old stone house with tiles on the floors and wooden beams in the ceiling and has a huge stone fireplace. The garden has a wide selection of herbs and, if you walk up the hill, there is a 360-degree view of the lake, the surrounding valleys and the nearby towns and villages, which have open-air markets at the weekends. I think it sounds like the perfect place for making memories.

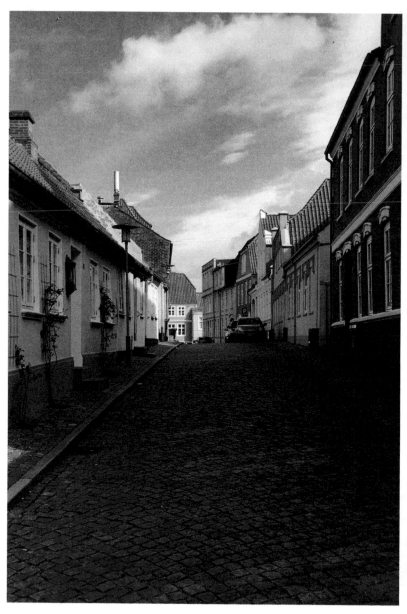

JUNE:
WALK DOWN MEMORY LANE

Remember how being somewhere we experienced happy times helps us to remember them—and how I asked my dad to organize a memory-lane tour of Aarhus? June is the perfect time for walks, so take your family or friends on a memory tour, or ask them to take you somewhere that means a lot to them.

On another occasion my dad and I visited the Old Town in Aarhus, an open-air town museum with seventy-five buildings you can enter and walk around in. Most of the buildings are from the mid-eighteenth to early nineteenth centuries—a tailor's, a blacksmith's, a brewery, and so on. The museum is populated by actors in period dress.

A small part of the Old Town is dedicated to the seventies and eighties. You can walk into apartments that look how I remember them looking back then—a grocery store with products from the eighties and a TV shop with records, tape recorders and deep-pan TVs. I instantly recognized the TV we had in our home and suddenly remembered how my dad and I used to watch Westerns in German.

I grew up close to the German border and, at the time, there was only one Danish TV channel so we would often watch German TV. My dad, who is half German, would translate. Walking into that TV store helped me understand why, until I was ten, I thought Clint Eastwood was German.

As a side note, the Old Town organizes "Memory Communication" tours for elderly people who are living with dementia. The museum has created an apartment furnished like a middle-class home from the fifties, where the surroundings may trigger memories for the guests.

JULY:
LAUNCH THE APOLLO PICNIC

First steps, first taste—first everything is always memorable.

Have you ever tried kimchi? It is spicy fermented cabbage, and it is delicious. It's hugely popular in South Korea, so much so that they say "Kimchi" instead of "Cheese" for photographs. Or how about a small piece of habanero chili? Or buckthorn juice?

July is the perfect time of year for a picnic. The weather is warm and the evenings are long, so invite your friends or family for a picnic. Make it a pot-luck event so everybody brings a dish to share—but the kicker is that everybody brings something they have never tasted before.

Call it the Apollo picnic and do it around July 20—the day of the moon landing in 1969. That way, you create an association trigger. By daring to do something new and testing your boundaries, you are also using the emotional highlighter pen. Also, the next time you see or taste the ingredients, a happy memory of a fun picnic will hopefully come to mind.

One small bite for man—one giant leap for memorable moments.

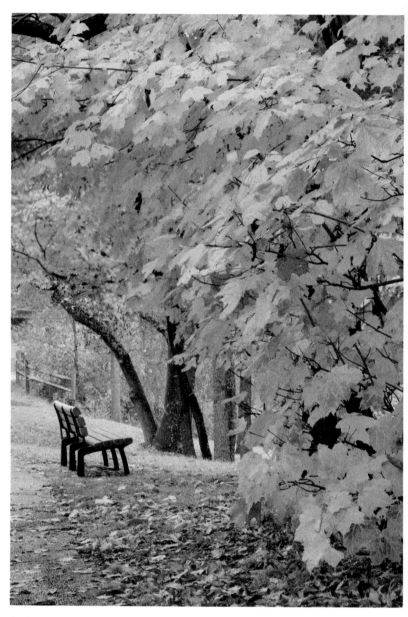

AUGUST:
TIME TO MIX UP THE ROUTINE

It's back-to-school or back-to-work month for people in Denmark (you may want to switch the month so it fits the cycle of the year where you live). This is the perfect time to mix things up and experiment with alternatives to your routine and the daily grind. Perhaps there is an alternative route to work or an alternative take-away place on your way home.

If you switch away from your default mode, you may slow down the pace of time a little—and perhaps you will discover that some of the alternative options are more enjoyable and turn them into your new routine.

SEPTEMBER:
FIND A PEAK WORTH THE CLIMB

We remember the times we struggled. Almost twenty years ago I spent four days in Sweden hiking with my girlfriend and two friends. We brought a kilo of rice, a kilo of onions and some chili sauce with us. We weren't inexperienced, we were just plain stupid. We were going to "live off the land." In addition, we brought one guitar, one saxophone and a moose hat— you know, the essential survival gear. To cut a long story short, we spent four days fantasizing about cake. Oh, and Mikkel's boot caught fire at one point. However, it did prove quite a memorable experience.

In the coming year, I plan to organize another hike, this time around the island of Bornholm. The 120km coastal trail is dotted with tiny villages, caves, castle ruins, waterfalls, smokehouses, Viking rune carvings, nature reserves, granite rocks and long white beaches.

September is the perfect time. It is off season but, as Bornholm is made of rock, the rock and the sea keep the island warm. There is also an abundance of figs, berries and mushrooms at this time of year, and flounders are still in season. So we might be stupid enough to add an additional challenge to the 120km hike and live off the land. Moose hat optional. So consider what your September struggle could be. Which peak would be worth the climb?

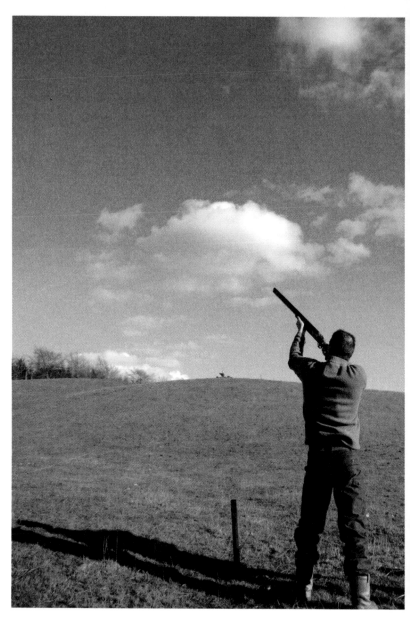

OCTOBER:
WAR OF THE WORLDS

Bring friends, or your kids—if they are old enough—to a clay-shooting range. For many people, this will not only be a novel experience but, because guns by default are dangerous, you are also using the emotional highlighter pen. (Of course, you should put safety first.) Furthermore, guns are loud. Gunpowder smells. And the view of a flying disc that suddenly shatters midair is rather exciting.

There will be extra points if you add a storytelling component. If you have kids—or gullible grown-ups—you might, for example, conjure up a story in which Earth is being attacked by Martians and that you need to take out the flying saucers before they land. As a warm-up, you could listen to the 1938 radio classic H. G. Wells's *War of the Worlds* read by Orson Welles. Every ten years, there will be mention and discussion of the anniversary of the time when "the broadcast terrified the nation." The following weekend you might watch the movie starring Tom Cruise and use it as a trigger to the memory to stay ahead of the forgetting curve.

NOVEMBER:
MAKE A LIST OF NEW THINGS YOU WANT TO TRY

Remember: studies show that we are better at remembering the novel and the new. Novelty helps durability when it comes to memory, so use November to harness the power of firsts. Novel November.

Make a list of new things you want to try out. You may want to visit a place you have never been to before, pursue a new hobby or learn a new skill. If you are able to acquire new skills, it gives you a sense of accomplishment and boosts your self-confidence—both have positive effects on your level of well-being. If you need ideas, you can get inspiration from the Action for Happiness "New Things November" calendar.

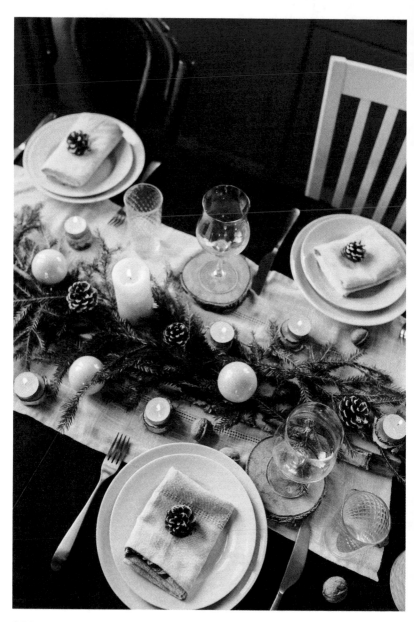

DECEMBER:
CURATE THE HAPPY HUNDRED

The days between Christmas and New Year's Eve are a good time to go over the digital photos you, and possibly your family, took this year. Share what you all thought were the happiest moments and select which hundred photos should be printed out.

It's similar to when you write down your ideas for a book or a business. Good ideas go on to your MacBook. Great ideas go into your Moleskine notebook. Special ideas get a special place—and your most special photos should get special treatment, too. So take active steps to preserve your photos and to protect yourself and your family from digital amnesia. Bring your photos out of the digital universe and into real print.

The act of being proactive in preserving your digital photos to make them last for decades and for the next generation might well be one more happy memory.

A RETURN TO ATLANTIS

Luis Buñuel, the Spanish surrealist filmmaker, once wrote that our memory is our coherence; it's experiencing being the same person over time. So, in the process of writing this book, I ventured back to my hometown to uncover happy memories, to connect with my past and to connect with the former self with whom I share a name.

Haderslev is a small town at the bottom of a fjord in the southern part of Denmark, about 50 kilometers from the German–Danish border. Some houses date back to the sixteenth century, and on one of the squares a couple of the old timbered houses lean up against each other like a loving old married couple.

I return to Haderslev one day in spring. It is election season and on the main street the Social Democratic Party is handing out fliers and free sausages and Bruce Springsteen's "Born to Run" is playing on repeat.

I retrace my steps around town. The library where I would borrow piles of books as a kid. The cinema where I worked nights when I was in high school. The town square where Mikkel and I sang Frank Sinatra songs while Mikkel held a hard-boiled egg, for some reason. I visit the butcher's, the cheese store, the bookstore in search of memories. In the bookstore, there is a familiar scent that reminds me of something. Hoping for a madeleine moment, I try hard to make the memory resurface but I am unable to recover it.

I visit the house I grew up in. It is on the outskirts of town, on a hill overlooking the fjord. It is a yellow brick house with a flat black roof, which I often used to climb up on, much to my mother's displeasure.

There is an inner courtyard with a Japanese cherry tree and, once in a while, pheasants would roam on the steep slope behind the house.

The new owners are lovely people. Steen is a law professor and Lene teaches the local boys' choir. We spend a lovely sunny afternoon drinking coffee and talking about the house and about memories.

The pheasants are gone. The Japanese cherry tree is still there—but not in the place where I remember it. My old room is now a library.

To be completely honest, this is my childhood home and my ego is a little bit hurt that it hasn't been turned into a museum yet. You can hardly walk past a building in Copenhagen without seeing a plaque stating that Hans Christian Andersen lived there, had coffee there or knew a guy who knew a guy who lived in the building. Nevertheless, I did refrain from giving the current owners a "Meik Wiking lived here" plaque to put outside their house.

Back in town, I browse in a vintage shop and buy a Kodak camera from the forties. I walk down the main street, turn my head to the left, see a shop in a small alley and step directly and instantly into a memory.

When I was sixteen I took a photo of a sunrise by Uluru in Australia. For some reason, I thought it was such a great picture that I asked a shop which sold posters back in Haderslev whether they wanted to sell it. That shop was located in the small alley I was now standing in. The memory led to another one: a conversation I overheard between my mother and a friend. "Do you really think he will be able to sell the photograph?" he asked. "Yes, I do," she answered.

I wasn't able to sell the photograph. But more than two decades afterwards, I was able to retrieve a memory of a parent believing in me. And that is worth something.

This year, I went to China for the first time. To Russia for the first time. But it was also the first time I had ventured so far into the past. We are all travelers—and we are all travelers in time, exploring the past and dreaming about a happier future.

Part of this quest was prompted by turning forty, by passing the halfway-there milestone to my date of expiration (statistically speaking). This journey backwards has allowed me to consider my journey forwards. The first half is gone. What should I do with the second half?

Seneca once wrote, "As long as you live, keep learning how to live." I think one of the courses in the school of life is about our time. What do we choose to do with it? Which of our past experiences have brought us the most happiness? I believe that looking back—revisiting our happy places and our happy times—enables us to plan for a better journey ahead. Plan for future happy memories. Plan for happier days. Plan for a happier future.

And remember: one day, your life will flash before your eyes—make sure it is worth watching. I hope it includes raw porridge on a windy beach.

PHOTOGRAPHY CREDITS

ABOUT THE AUTHOR

───

Meik Wiking has been described by *The Times* as the happiest man in the world. He founded the world's first Happiness Research Institute in 2013, in Copenhagen, Denmark. In addition, he is research associate for The World Database of Happiness and part of the advisory group to the Global Happiness Policy Report.

He consults cities, governments and companies around the world on happiness and how to convert wealth into well-being. He has been a keynote speaker in more than forty different countries.

He holds a degree in business and political science and previously worked for the Danish Ministry of Foreign Affairs. When he's not writing books (including the internationally bestselling *The Little Book of Hygge* and *The Little Book of Lykke*) and reports on happiness, well-being and quality of life, he enjoys photography and playing tennis (quite badly).

Instagram @meikwiking
Twitter @meikwiking
Facebook @meikwiking1

THANKS

I would like to thank the people who helped create the following memories. Thank you for the underground tunnels and tree-top fortresses. For the snowball fights and skating Friday nights. For the smell of grass at Solbæk and for opening another bottle of red wine at Christmas. For Irish coffee on the deck and skateboarding down the street. For the extreme survival trip in Skåne and for chicken roasting over an open fire under the stars. For riding the jeep on Fejø and for the duels on the tennis court. For firm bottoms, sparkling minds and looking for the beauty in the world. For Pastis and Pétanque and for the applying happiness research in the water park. For hiking up Mount Fuji and skiing down the slopes. For the trips to Kelstrup, the blue mohawks and for the gu-gu-gu-gu. For letting me into the Hallowe'en party even though I was dressed as a smølf. For too much rock 'n' roll for one hand, the battle of Kronborg Castle and making sure Ban Ki-moon's water glass is filled 4/5ths. For midnight orange cannons and for listening to 'In the Air Tonight' across the Australian outback. For opening the restaurant after hours and for a piece of paradise too beautiful not to share. For horse races, after-work swims and for a flawless version of 'You've Lost That Loving Feeling'. For the hockey matches, the movie nights and the birthday in Paris. For countless coffees and endless conversation and for the sausage disaster of 2015. For dancing to 'My Sharona' and for Beethoven-infused boardgames. For expanding the *Oxford Dictionary* and taking *hygge* around the world. For the Salt Lake Shamanism and fighting with me to make the world a happier place. For strong coffee and soft kisses on Sunday mornings.